THE Best OF Aubrey Beardsley

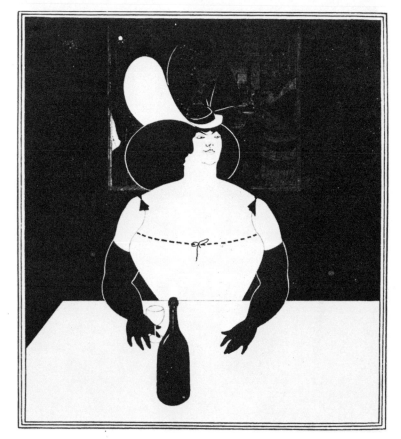

THE Best OF Aubrey Beardsley

by

KENNETH CLARK

AN
ARTABRAS
BOOK

Doubleday and Company, Inc.

NEW YORK, N.Y.

AUBREY BEARDSLEY

Library of Congress Cataloging in Publication Data

Beardsley, Aubrey Vincent, 1872–1898.
The best of Aubrey Beardsley.

Bibliography: p.
Includes index.
1. Beardsley, Aubrey Vincent, 1872–1898.
I. Clark, Kenneth McKenzie, Baron Clark, 1903–
II. Title.
NC242.B3A4 1978 741'.092'4 78-7061

0-385-14543-8

· Printed and bound in the U.S.A.

Contents

Foreword

THIS BOOK evolved in three stages. The first was a lecture given at the Aldeburgh Festival in 1965. At that time the name of Beardsley was almost completely forgotten, and I remember that as I was going into the hall I heard a young lady say to her companion, "Who is this extraordinary man he's talking about?" to which her escort replied, "Some sort of wishy-washy Pre-Raphaelite I believe." The lecture was repeated in the Victoria and Albert Museum later in the same year. For some mysterious reason by that time Beardsley's reputation had begun to revive; the hall was full and the audience enthusiastic. Meanwhile, Mr. Brian Reade had begun to organize a great Beardsley exhibition, which took place in London in 1966 and in New York in the following year. Mr. Reade brought to the study of Beardsley a thoroughness and a breadth of knowledge hitherto undreamed of, and his catalogue of the exhibition is a classic work of scholarship. The exhibition attracted large crowds, and a Beardsley boom set in. Dress designers copied him. The young lady in *L'Education Sentimentale* was a favorite model (see pl. 31). Shop windows were arranged in the manner of Beardsley drawings. Mr. Cecil Beaton dressed and designed the Ascot scene in *My Fair Lady* in black and white. Finally, in 1969, Luchino Visconti did a production of *La Traviata* in the Beardsley manner, with certain properties actually taken from Beardsley drawings. Then, as always with Beardsley, the boom subsided. He was not exactly forgotten, but he became an historical curiosity.

Meanwhile, in 1967, Mr. Brian Reade published his masterly book, which makes any further writings on Beardsley superfluous. It contains 502 illustrations with scholarly notes.

In 1976, I was asked by *The New York Review of Books** to write a piece on Beardsley to coincide with the publication of a short, useful book by Brigid Brophy in which, unfortunately, she had repressed her gift of critical insight and has concentrated on the facts of Beardsley's life. I looked up my earlier lecture and, after various excisions, produced a printable piece. For some reason this took the fancy of Mr. Harry N. Abrams, who asked if he could publish it as a book. I declined, as it added nothing to what was known already. But finally he persuaded me that a small book with about sixty illustrations might be welcome to the amateur, and also suggested that I should write free comments on each of the plates. This seemed to have certain advantages. For example, I could stress how often Beardsley's design (as opposed to his imagery) anticipates contemporary painting and could relate it to hard-edge abstraction. His influence on the pioneers of contemporary painting—Munch, Klee, and Picasso—was already known, but needed to be emphasized.

The reader may ask on what basis I selected the drawings. The first criterion was excellence. Beardsley produced over 600 drawings in five years interrupted by bouts of illness when he could not work. Inevitably some of these are trivia, although even among his little illustrations to *Bon-Mots* there are fascinating inventions. My second consideration was to give a fair idea of Beardsley's character. Apart from

*I am deeply indebted to the *New York Review of Books* for allowing me to use what is to a large extent a reprint of this article in a book.

8

his prodigious gifts, his remarkable personality quietly dominated any society he was in. The mixture of naughtiness and genuine religious feeling, of mischief and repentance, thought to be common in the 1890s, was more really the inheritance of Beardsley. It was he, and he alone, who gave *The Yellow Book* its character; after his dismissal it lapsed into banality.

Thirdly, I must confess that this is a personal choice. It omits a number of drawings that are thought to be among his masterpieces. For example, I do not include the illustrations to *The Works of Edgar Allan Poe,* although Beardsley took on this work with enthusiasm. They seem to me too obvious and lack the subtlety and irony that distressed Oscar Wilde in his *Salome* drawings. I have omitted the Wagner drawings, rather reluctantly, because although Beardsley idolized Wagner, their lack of structure, presumably intended to convey the endless flux of Wagner's music, makes me feel uneasy. Beardsley was above all an architectural artist.

Finally, I have omitted the indecent drawings. Shortly before his death, Beardsley wrote to Leonard Smithers the following letter: "Dear Friend, I implore you to destroy *all* copies of *Lysistrata* and bad drawings. . . . By all that is holy *all* obscene drawings." This request represented the earnest wish of a man of great depth of character, who was in full possession of his faculties, and should be respected by anyone who admires him. I may add that the omission of these drawings does nothing to change one's opinion of Beardsley as an artist; indeed, they have less erotic impact than many of his drawings which are not overtly indecent.

K.C.

Aubrey Beardsley

INTRODUCTION

IN APRIL, 1893, there appeared a new art periodical called *The Studio*, and, to the scandal of all established art lovers, the principal article was devoted to the drawings of an unknown boy of twenty-one named Aubrey Beardsley. The scandal was not due simply to the fact, regrettable enough in that age of solid reputations, that he was young and unknown, but to the character of the drawings themselves. Aestheticism had already shown its head. Gilbert and Sullivan's *Patience* was more than ten years earlier; but nothing, not even Wilde's *The Picture of Dorian Gray*, which had been published two years before, had been so openly and defiantly *fin-de-siècle* as these four drawings by Aubrey Beardsley. Unhealthy, the word most often used, was not without justification. As Walter Pater, the father of English aestheticism, said of a famous passage in Coleridge, "What a distemper of the eye and mind! What an almost bodily distemper there is in that!"

How perfectly these words are illustrated in one of the drawings in *The Studio* called *Les Revenants de Musique* (pl. 3), which is a good deal the mildest of the four, because the whisper of temptation is extremely faint. Beardsley's other drawings not only lacked the manlier virtues; they positively suggested vice as a more interesting alternative; and they did so with an adolescent intensity which communicated itself through every fold and tightly drawn outline of an ostensibly austere style.

No wonder Beardsley's drawings became a kind of catmint to adolescents, and continued to be so for almost thirty years. I was one of the adolescents thus bewitched. Sixty years ago I was producing pastiches of Beardsley with an excitement which I have seldom felt since. I remember my housemaster discovering one of them in my desk and saying, "It's erotic and neurotic, and I won't have it in my house." My housemaster's

REPRINTED WITH PERMISSION FROM *The New York Review of Books*. COPYRIGHT © 1976 NYREV, INC.

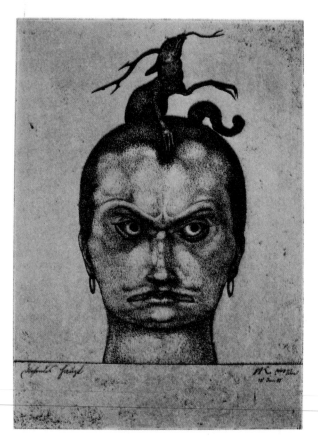

Paul Klee. *Menacing Head*. 1905.
Kunstmuseum, Berne, Switzerland

comment, although correct as far as it went, was incomplete; and I like to think that I was not only fascinated by Beardsley's sexual depravities but that I had already recognized his extraordinary powers of design.

It was, of course, the complete originality of his style, not his subject matter, which accounted for Beardsley's influence on the pioneers of modern art—Munch, Klee, Kandinsky, Mackintosh, and Picasso himself— to say nothing of such minor artists as Félix Vallotton. In many of their early works a debt to Beardsley is unquestionable. It is a formidable list, and I think justifies us in taking a fresh look at an artist who, if he is remembered at all, is often remembered for the wrong reasons.

The facts about his early life have recently been collected in a scholarly manner by Brigid Brophy. He was born in Brighton in August, 1872. His father was a consumptive with a small private income, "not out of the top drawer," as we English used to say with satisfaction in the last century; his mother was a Miss Pitt, a local charmer, known on account of her

12

excessive slenderness as "the bottomless Pitt." Beardsley's famous drawing of Mrs. Patrick Campbell (pl. 34) is done with such love and is so unlike its ostensible subject that I incline to think it was an ideal image of Mrs. Beardsley. She was the dominant influence on his life and was absolutely unshockable. She lived on in Brighton till 1923, but like an ass I never went to see her.

Brigid Brophy rightly stresses the importance of Brighton to Beardsley's pictorial imagination. One finds in his drawings not only the crazy rococo-cum-chinoiserie of the Pavilion, but the severe frontality of the Brighton terraces, which form a background in his frontispiece to Juvenal (pl. 41). As a boy he also had a passion for acting. Mr. C.B. Cochran, who was his companion in the Brighton Grammar School, told me that he had a program of a play they had put on together. It said "Producer Aubrey V. Beardsley, scenery and costumes by Charles B. Cochran." Unfortunately, he always forgot to show it to me—but he swore it was that way round. Beardsley was also an insatiable reader; Max Beerbohm said that he was the best-read man he had ever known. His favorites, even at school, were Ben Jonson, the Restoration dramatists, Racine, Molière, Balzac, and *Manon Lescaut;* strange choices for a boy of fifteen.

On leaving school he entered an architect's office. He seems to have been there for not more than a few months, but it was the only training in art to have any effect on him. Not only are the architectural settings in his drawings done with professional knowledge, but there is in many of them an architectural sense of space which was to influence one of the founders of modern architecture, Charles Rennie Mackintosh.

All the memories of his life (one can't call them biographies) say that he was helped by Pierre Puvis de Chavannes in Paris, and in one of his first evolved drawings, *The Kiss of Judas* (pl. 15), there is a reminiscence of the background of Puvis's *Pauvre Pêcheur,* that masterpiece of imaginative painting that was later so deeply to influence Picasso. But no one says precisely when he went to Paris or what he saw there. Did he see the work

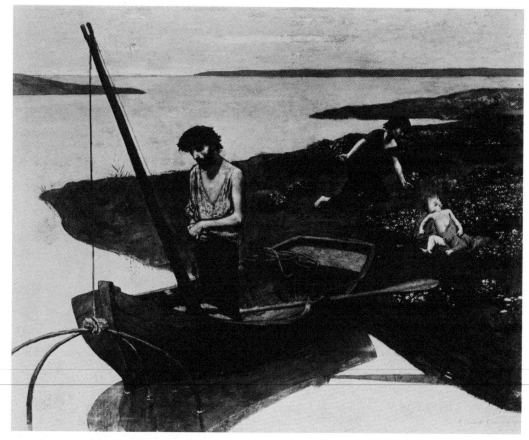

Pierre Puvis de Chavannes. *Pauvre Pêcheur*. 1881. The Louvre, Paris

of Gustave Moreau? He certainly saw the work of Odilon Redon, as quotations from Redon appear in his work. But such influences are not important because in art, as in literature, Beardsley was not much interested in his contemporaries; and if he arrived at similar results it was by following independently the same route, that is to say, by reinterpreting certain artists of the *quattrocento,* notably Mantegna, in a vein of romanticism. The dwarf to the left in Botticelli's early *Nativity* in the London National Gallery was undoubtedly a favorite, and Crivelli's disenchanted *St. Catherine* has a preciosity as provocative as any Beardsley.

In his admiration for the linear, decorative style of *quattrocento* art he was, of course, only prolonging the direction of the later Pre-Raphaelites; and a visit to Edward Burne-Jones changed his life. Burne-Jones was at the time considered by serious people the greatest living English artist.

He was besieged by earnest admirers and had very sensibly closed his studio and received no visitors, but he saw Mabel Beardsley's red hair from the window, and let the young brother and sister in. Beardsley had his portfolio with him, and the moment Burne-Jones saw its contents he said, "You will become a great artist." They spent the rest of the day there and came home, Beardsley tells us, "with the Oscar Wildes—charming people."

Of all the artists who sacrificed their talents to the timidity of Victorian taste, Burne-Jones was the most gifted. Although he lacked the pas-

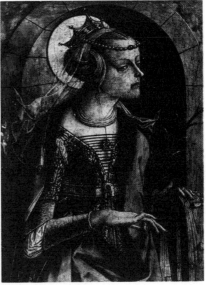

Carlo Crivelli. *St. Catherine*. National Gallery, London

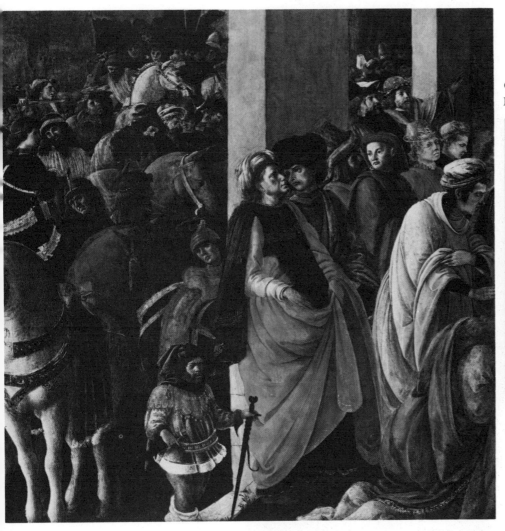

Sandro Botticelli. Detail from the *Nativity*. National Gallery, London

Edward Burne-Jones. *King Cophetua and the Beggar-Maid.* 1771. Tate Gallery, London.

sion of Dante Gabriel Rossetti, he had far greater skill and more varied invention. But remembering what Rossetti's undisguised sensuality had cost him in abuse, he decided to exclude his own very intense feelings for the body on the pretext of a kind of idealism. As a result even his finest work, like the Orpheus drawings, have a disembodied prudery which has been the death of them.

Beardsley felt this instinctively. In his first great drawing, *The Litany of Mary Magdalen* (pl. 2), the figure on the right is pure Burne-Jones, both in style and feeling; but the scene she witnesses is no Pre-Raphaelite paradise. The Magdalen, in an agony of remorse, is mocked by four horrible creatures, a sneering man and woman, a depraved old monster, and the first of those malicious dwarfs of which Beardsley was so fond. This is the earliest example of that obsession with evil which dominates Beardsley's art, and of which I shall have more to say when I come to the drawings for Wilde's *Salome*. It is Burne-Jones gone to the Devil; but it remains Burne-Jones with an admixture of Mantegna. How deeply the subject, the mockery of repentance, was embedded in his imagination is shown by the fact that he came back to it two years later, when his own style was fully formed.

Beardsley is one of the rare artists who did not have to wait for recognition. His technical skill alone secured it; and at the age of twenty, under the superficial impression that he was a second Burne-Jones, he was commissioned by J. M. Dent to decorate an edition of Malory's *Le Morte Darthur*. It was to be a sort of commercial Kelmscott Chaucer. The commission, which seemed like a stroke of luck, for it released him from an insurance office, was to some extent a misfortune. Beardsley had to produce hundreds of decorations and elaborate borders. It took him two years, during which time he had outgrown his Pre-Raphaelite phase; and many of the drawings show signs of boredom and irresponsibility. Even those which are done with excitement are singularly unsuitable, for Beardsley's love of evil is perceptible in nearly all the faces. No wonder William Morris was displeased by this macabre parody of his style (see pl. 5).

Le Morte Darthur is an incredible accomplishment for a boy of twenty, both in the elaborate borders and in the illustrations, and the best of them anticipated and equaled his mature style. In *How La Beale Isoud Nursed Sir Tristram* (pl. 6) one finds that perfect disposition of absolute blacks for which Beardsley was to become famous, in a setting that is far closer to our own time than that of William Morris. In *How Queen Guenever Made Her a Nun* (pl. 10) the unrelieved black of the beautiful figure (done with unusual feeling) is contrasted with a rich decorative background that carries the movement of the border into the picture. Perhaps the only objection to the *Morte Darthur* illustrations is that, seen in the original volumes, one becomes sated and overlooks some beautiful pictorial and human inventions in the chapter headings (see pl. 7). In a selection one's interest is revived.

The *Morte Darthur* drawings are in a bold black and white suitable for reproduction in a printed page. But at the same time Beardsley did at least two very elaborate drawings in thin, spindly lines, which could only have been reproduced photographically (pls. 4, 11). One of them, which is supposed to represent Siegfried (a Siegfried who never gave tongue in Bayreuth), is an early masterpiece. There are still memories of Burne-Jones in the elegantly un-Wagnerian figure: but, Oh! Burne-Jones, thou art translated! These diabolical black wings which sprout mysteriously from all over the figure of Siegfried are very far from Burne-Jones's virtuous shapes, and so are the *fleurs du mal* growing out of the dark lake.

These were two of the drawings that Beardsley carried around in his portfolio and placed silently, with a bow, in the hands of anyone who showed any interest. And in Mrs. Alice Meynell's drawing room he showed his portfolio to Lewis Hind, then the least objectionable critic in England. Hind said, "You are a genius, and I shall reproduce your work in the first number of *The Studio.*" In fact he did reproduce these drawings, and, later, two almost equally surprising. One of them, called *The Birthday of Madame Cigale* (pl. 12), introduces a new element in Beardsley's art, the influence of Japanese prints.* The art of Japan had

* In fact the very first instance seems to be a drawing called *La Femme Incomprise*. I have never seen the original, which seems to be lost.

already influenced Toulouse-Lautrec. But it was very largely through Beardsley that certain decorative elements of Japanese design were reinterpreted so that they became part of a new European style.

The story is well known. In 1862, the Japanese, breaking out of their isolation for the first time, sent quantities of decorative objects to the International Exhibition in London. These horrific artifacts (for Japanese art was thoroughly corrupted long before Commodore Perry anchored in Uraga Bay) remained unsold, and the stock was taken over by Mr. Arthur Lasenby Liberty. Such was his success that the style which we call Art Nouveau was known in several other European countries as the "style Liberty." From Liberty's come all those unstructural plants and those vagrant lines which give to every area the character of damascene brocade. There is an even more obvious reference to the old Oriental department of Liberty's (still going in my youth) in the predella of *The Birthday of Madame Cigale*. But in *Madame Cigale* the severe and economical line with which these far from admirable characters are drawn informs us that Beardsley had found a new source of inspiration—one which was to mean incomparably more to him than Japaneseries—the fifth-century Greek vases in the British Museum. In the recent revival of Art Nouveau, Beardsley is sometimes claimed as a representative of the movement. But with rare exceptions his style is far more classical and closer to Duris than to Mucha.

The fourth drawing in *The Studio* is the most disturbing. It represents Salome kissing the decapitated head of St. John the Baptist (pl. 13). A long stream of blood drops into a dark pool. In style and sentiment it is genuinely decadent. No wonder decent people were frightened by the young genius.

In the *Studio* drawing with which this essay began (pl. 3), the economy, the parallelism, and the fastidious placing of each accent suggest yet another influence—one from which no intelligent young artist in the 1890s could easily escape: Whistler. Beardsley's few published letters almost all mention Whistler, but even without them we

could not fail to recognize the source of these plain rectangular bands and of this very simple, unaccommodating chair. Even now we hardly realize how much the simplicity which distinguishes modern interior decoration from that of any other epoch derives from the desire for perfection of that imperfect genius. The plain distempered walls and single flower on its spindly table were the first steps in that suppression of ornament which culminates in Mies van der Rohe and Philip Johnson.

Beardsley was well aware of his debt to Whistlerian economy, and with his usual mischief repaid it by a caricature of the maestro (pl. 29), unmistakable with eyeglass and patent leather shoes, pointing to his famous butterfly. It is brilliantly designed but, not surprisingly, Whistler was annoyed and spoke disparagingly of Beardsley. "Why do you get mixed up with such things?" he said to Joseph Pennell, "Look at him. He's just like his drawings, he's all hairs and peacock plumes—hairs on his head, hairs on his finger ends, hairs in his ears, hairs on his toes." He was probably thinking of the *Siegfried*. But when later he was induced to look at some of Beardsley's drawings, he said, "Aubrey, I have made a mistake. You are a very great artist." Beardsley wept. All Whistler could do was repeat, "I mean it, I mean it."

Not only Whistler's dandified austerity, but also the richness of his Peacock Room had its effect on Beardsley. Peacocks, of course, were everywhere in the 1890s, and played a leading part in the iconography of Art Nouveau; but we know from a letter and many sketches that Beardsley visited the Peacock Room just before beginning his *Salome* drawings. The illustration to *Salome* called *The Peacock Skirt* (pl. 18) is perhaps the most direct borrowing in the whole of Beardsley's work.

With the illustrations to Wilde's *Salome,* we reach the point in Beardsley's work at which he is completely sure of his means and of his imagination. They were commissioned by John Lane in 1893 on the strength of the fourth *Studio* drawing to which I have just referred, *J'ai baisé ta bouche Iokanaan* (pl. 13). It would be fascinating to know what discussions took place between author and illlustrator, but the books on

James McNeill Whistler. *Peacock Room.* 1876–77. The Freer Gallery, Smithsonian Institution, Washington, D.C.

Beardsley tell us nothing except that his first enthusiasm for Wilde gradually cooled. It is possible that Wilde, then at the arrogant height of his success, was patronizing to Beardsley, implying that the young man was rising to fame as a satellite of his poetic genius. Beardsley, whose favorite authors were Ben Jonson and Racine, must soon have recognized *Salome* for the rubbish that it is, and may have had a fair idea that it would be remembered solely as the pretext for his drawings. This is the kind of feeling which it is hard for a young man to conceal. Moreover, his

naughtiness got the better of him, and, as with Whistler, he included among the illustrations a perfectly gratuitous caricature of Oscar Wilde as *The Woman in the Moon* (pl. 17); one of his most original drawings, with a strangely Kandinskian movement—but unlikely to please the poet.

Whatever Beardsley may have felt about Wilde's *Salome* as literature—and it is said that he translated it from the original French into English—he accepted it as a source of inspiration. It was the ideal pretext for exploiting his sense of evil. His drawings exhale an aroma of sin, compared to which Wilde's writings are quite harmless. Wilde's character, as we all know, was sunny and shallow; his attempts to com municate with the powers of darkness were as frivolous as his overtures to the powers of light. But for some mysterious reason Beardsley had a direct line to the Evil One and his communications are perfectly serious. In the drawing entitled *Enter Herodias* (pl. 23), the showman, whose face is a reminiscence of Oscar Wilde, introduces an embodiment of Evil who rises above her two degraded companions with authentic majesty. This familiarity with evil seems to have been intuitive and innate. He practically never mentions the two high priests of nineteenth-century diabolism, Baudelaire and Huysmans, although the titles of their books, *Les Fleurs du mal* and *A rebours,* so perfectly describe his own attitude. He seems to have read *Les Fleurs du mal,* for he gave a copy to Sir William Rothenstein, but in general he was uninfluenced by any near-contemporaries, except Wagner. It was a do-it-yourself diabolism.

Enter Herodias is the drawing in the series in which the presence of evil *s'affiche au premier plan,* and I may be forgiven for returning to it to point out one or two particularly disturbing details. First of all, the curious symbol of depravity who holds back Herodias's cloak. He appears quite early in Beardsley's work, looking like a bad-tempered, elderly fetus. Nothing could show more clearly Beardsley's impatience with the idealistic strain in Pre-Raphaelitism than that in another drawing (pl. 14) this repulsive goblin should be pointing to the first words of the *Vita Nova,* the sacred fount of the whole movement. The scale and the abstrac-

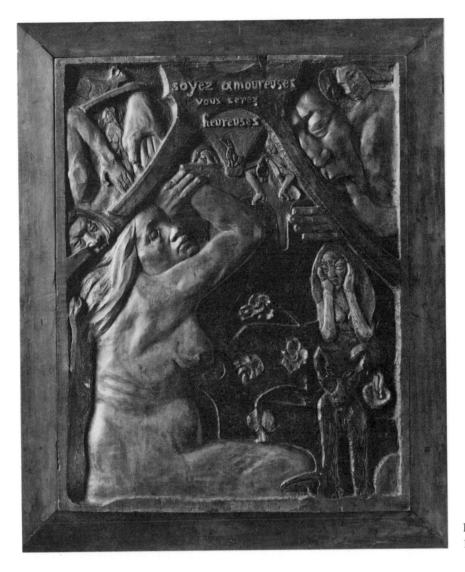

Paul Gauguin. *Be in Love, You Will be Happy*.
1889. Museum of Fine Arts, Boston

tion of this work are extremely curious and make me wonder if Beardsley,
in his early visit to Paris, had not seen some drawings or reliefs by
Gauguin, who, about a year earlier, had evolved a very similar type of
grotesque symbolism. Impossible to prove, but I reproduce one of them,
dated 1889, which shows that Beardsley, for all his archaism, belonged
instinctively to the avant-garde of symbolism.

Another detail of the Herodias drawing of interest to the art historian
is the owl's head and mercurial crutch of the showman, or announcer on
the right. The rhythms, the stylized bird, and the use of dots remind one

of Celtic ornament and suggest that Beardsley knew John Westwood's *Facsimiles of the Miniatures and Ornaments of the Anglo-Saxon and Irish Manuscripts* (1868). Thus the Celtic element which was to play so great a part in Art Nouveau, ultimately ousting the Japanese, was also one of his discoveries. Through the *Salome* drawings it was transmitted to Mackintosh and the Macdonald sisters with results which would, if examined, take us too far: in fact all the way to Louis Sullivan and the early work of Frank Lloyd Wright.

Technically the most extraordinary feature of the drawing is its simplification. Beardsley leaves out everything which doesn't contribute to his effect. Herodias stands on nothing. The goblin (who has no ear) sits on nothing. I doubt if any artist with a conventional academic training could have allowed himself such drastic elimination. He could not have left the large white area of Herodias's cloak without some indication of its modeling.

In some of the drawings this disregard for actuality is carried even further. In *The Eyes of Herod* (pl. 20) the figure to the right is wholly inexplicable in concrete terms. The design coheres through a balance of line and area and the skillful relationship between plain black and white and the highly wrought ornamental texture (peacocks again) on the left. In most of the *Salome* drawings the personages still show traces of Pre-Raphaelite nostalgia. In some of them the sinister accouterments are rather closer to Gustave Moreau—but, at any rate, they are romantically backward-looking. But in some of the later *Salome* illustrations, Beardsley applies abstractions to contemporary dress (see pl. 22). The same disregard for actualities which allowed him to eliminate anything which he could not absorb into his system of design left him free from all anxieties about period or probability. Salome, who in her interviews with St. John is dressed as an Eastern (I suppose) princess, reappears in an extravagant black cape (see pl. 19), which must owe something to the lobster carapaces of Sharaku's actors, but is, in general effect, entirely of its time.* The result is to liberate Beardsley's sense of design. He escapes

* I have seen it stated that this drawing was not intended for the *Salome* series and was included as an afterthought.

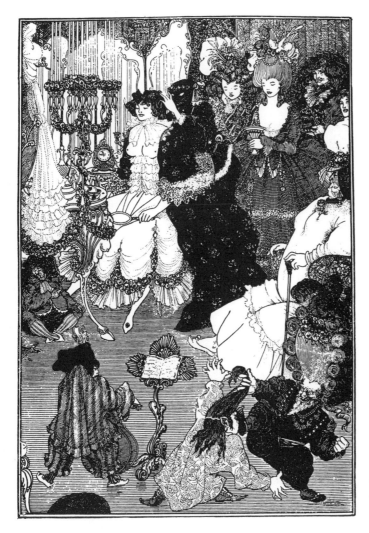

Aubrey Beardsley. *The Toilet*. 1896.
Illustration to *Under the Hill*, Chapter II

from the effete and monotonous rhythms of Pre-Raphaelitism to a more vigorous abstraction. The cloak becomes a kind of totem, like a sinister bird on a Mayan plaque.

An even stranger piece of hard-edge abstraction is the second drawing for *The Toilet of Salome* (pl. 21), with its Whistler-Godwin furniture and its hint of a modern interior. The complete exclusion of anything, any conventions or probabilities, which does not contribute to the essence of the design is startling. No wonder the young artists of the 1890s who felt the need for abstraction—Kandinsky and Klee—looked with astonishment at this drawing, and at the precision with which Beardsley has extracted these shapes from the cloak and related them to the chair. To

realize his disquieting originality, one may turn to an analogous drawing by Walter Crane, done in almost the same year. For twenty years Crane had been the unchallenged leader of decorative illustration in England, admired (and rightly) by people of taste and sound judgment. Sir William Rothenstein, for example, has recorded that he much preferred Crane to Beardsley. We may agree that Walter Crane was likely to have a healthier influence on students; but as to which of these drawings is related to the lively art of its time there can be no reasonable doubt.

Beardsley's output during the autumn of 1893 is almost incredible. In between the *Salome* drawings he continued the grind of *Le Morte Darthur*. He did drawings involving laborious detail, like the exquisite portrait of Madame Réjane (pl. 27), where the pattern of the skirt is all executed by the point of his pen, as if to express his devotion to the living artist he most admired. He also did a number of odd jobs—some of them of a surprising kind—*bons mots*—tryouts. What the lady golfers of Mitcham made of the card (pl. 28) I can't imagine. Lane persuaded him to design the covers and title pages of many long-forgotten novels which were the chief output of Lane's publishing firm, the Bodley Head. Although inventive and faultlessly executed, these covers were a waste of precious weeks, as they are often in the backward-looking ornamental style of William Morris. But a few are pure Beardsley (see pl. 42); they look across the channel to the triangular sleeves in the posters of Jules Chéret that so much influenced Seurat.

Convinced of Beardsley's adaptability and technical skill, Lane then conceived the idea of an illustrated quarterly of which Beardsley would be the art editor. The prospectus (pl. 30), in which his absolute black and white is used to create an effect of light, appeared in the spring of 1894. *The Yellow Book* remained for thirty years a symbol of naughtiness and corruption. In fact the contents are almost entirely harmless—stories by Henry James, Arnold Bennett, and by the blithe, innocuous editor, Henry Harland, drawings by Sir Frederic Leighton, poems by William Watson. But across this respectable gathering fell a long shadow, the

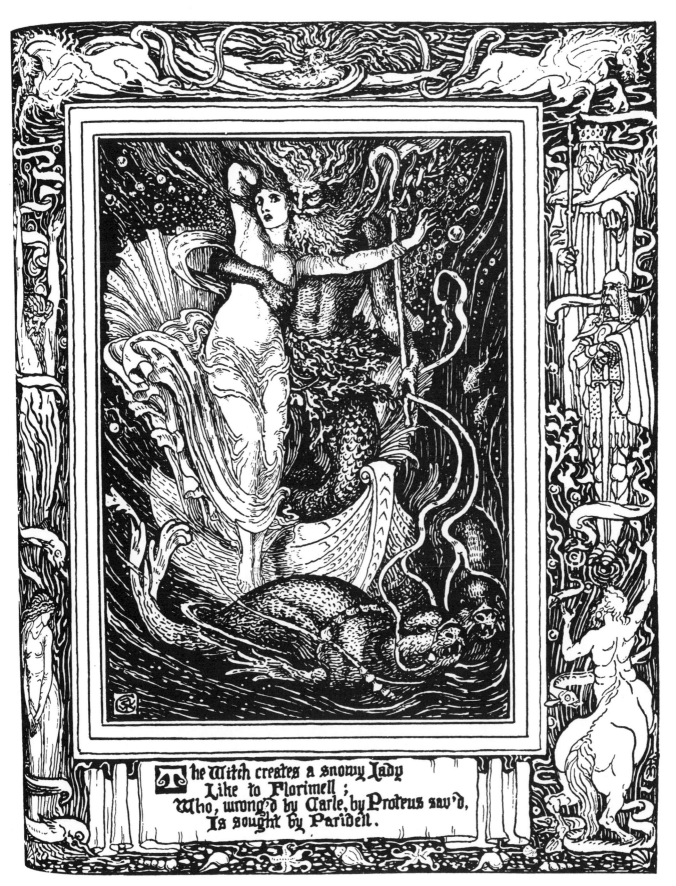

The Witch creates a snowy Lady
Like to Florimell ;
Who, wrong'd by Carle, by Proteus sav'd,
Is sought by Paridell.

Walter Crane. *The Snow Lady* from Spenser's *Faerie Queen*. 1894–97.

shadow of Aubrey Beardsley. It was he and he alone who gave *The Yellow Book* its character and its reputation. After four numbers he was dismissed because his name was connected with that of Oscar Wilde. William Butler Yeats, in *The Trembling of a Veil,* describes the episode:

> He had illustrated Wilde's *Salome,* his strange satiric art had raised the popular press to fury, and at the height of the excitement aroused by Wilde's condemnation, a popular novelist, a woman who had great influence among the most conventional part of the British public, had written demanding his dismissal. "She owed it to her position before the British people," she had said. Beardsley was not even a friend of Wilde's—they even disliked each other—he had no sexual abnormality, but he was certainly unpopular, and the moment had come to get rid of unpopular persons. The public at once concluded—they could hardly do otherwise, he was dismissed by telegram—that there was evidence against him, and Beardsley, who was some twenty-three years old, being embittered and miserable, plunged into dissipation.

The lady novelist was Mrs. Humphrey Ward, and she was not the only important person to protest. Lane, who was in America at the time, received dozens of telegrams from the leaders of literary England, including William Watson, who was tipped for the laureateship, demanding Beardsley's dismissal. He kept them—they are now in the library at Princeton, a monument to British hypocrisy. He saw all his authors leaving him, was seized with panic, and sent Beardsley the telegram to which Mr. Yeats refers. I should add that Lane was later filled with remorse and continued to blame himself for his cowardly action till the end of his life. Mr. Yeats does not specify the kind of dissipation into which Beardsley plunged. It can hardly have been drink, as his hand continued to produce fresh marvels of precision and control, and I even doubt if it was women, as the only woman he loved was his sister Mabel. As a student of Egyptian

history I see the merits of incest; there is no firm evidence that Aubrey's relationship with Mabel was incestuous, but she was his constant companion and the chief influence on his life.

The Yellow Book drawings fortunately continue the practice of the later *Salome* drawings in that the subjects wear contemporary dress. The first of them, *L'Education Sentimentale* (pl. 31), contains one of those creations which have recently proved so attractive to dress designers. It is—or was until he cut it up—one of Beardsley's most enchanting drawings. The pen outline is marvelously suggestive and even, by some miracle, suggests the weight of the wicked old party on the left. The breath of evil, though perceptible enough, is less insistent than in the illustrations to *Salome.* Beardsley is often described as a satirist—Mr. Yeats, in the passage I have just quoted, referred to his "strange satiric art"—and this drawing could be cited to support this classification. In general I rather doubt if the word can be accepted. The great satirists, Swift, Juvenal, Hogarth, have a two-faced relationship with vice. Their claim that they are concerned with it only in order to correct it is, of course, humbug. It fascinates them, and they portray it with obvious relish. But at the same time it frightens them and therefore rouses their moral indignation.

Beardsley had no feelings of moral indignation at all. The nearest he ever got to satire is a drawing in the third volume of *The Yellow Book* called *Lady Gold's Escort* (pl. 38); but even there the fantasy of these corrupt characters with their white muffs has delighted him. It is interesting that this drawing anticipates by fifteen years the appearance in Paris of the Russian Ballet, for nothing more Diaghilevian could be imagined. The principal escort even has a prophetic resemblance to Nijinsky. No wonder the young Diaghilev, on seeing the drawing, wrote to D. S. MacColl to ask for information about the artist.*

The Wagnerites (pl. 39), in the same volume of *The Yellow Book,* is usually claimed as a satire. But Beardsley adored Wagner, not least because of the sensual diabolism which he rightly divined in his music and which he has so marvelously reflected in the heads and naked shoulders of

*He retained his admiration, tried to buy the *Mademoiselle de Maupin* drawings and is said to have met Beardsley in Dieppe.

his admirers. As for the fat woman in *L'Education,* we know that Beardsley doted on her, loved her, indeed so much that he cut her out, colored the drawing, and mounted it separately (pl. 32). She is described in his novel *Under the Hill* as Mrs. Marsuple. "Mrs. Marsuple's voice," he says, "was full of salacious unction; she had terrible little gestures with the hands, strange movements with the shoulders, a short respiration that made surprising wrinkles in her bodice, a corrupt skin, large horny eyes, a parrot's nose, a small loose mouth, great flaccid cheeks, and chin after chin. She was a wise person and Helen loved her more than any of her servants, and had a hundred pet names for her," and there follow about twenty of the pet names in Rabelaisian profusion. He is talking of a drawing in which he depicts her superintending the toilet of Helen, and, although this drawing is two years later, and Beardsley's style has changed since *L'Education Sentimentale,* Mrs. Marsuple has remained the same.

The fact is that Beardsley gloried in those figures which seemed to embody the acme of corruption. Only in his two drawings of *Messalina* (pls. 45, 58) does one detect a slight feeling of repulsion. The earlier one, in the Tate, has a certain hellish grandeur, but *Messalina Returning from the Bath,* one of his last great drawings, is done with real ferocity. This *is* satire, and worthy of the Juvenal that it illustrates.

It is arguable (although Beardsley himself would not have agreed) that *The Yellow Book* drawings show him at his best. At all events they suggest a point at which we should ask a few more questions about his peculiar skill as a draftsman. How did he achieve the perfection, certainty, and aplomb of *L'Education Sentimentale?* Beardsley himself took pains to ensure that we should not know the answer. Nobody saw him at work.* He locked himself in his room, pulled the curtains, and did his drawings by candlelight. He managed to destroy all but two of his original studies and tried to erase the traces of preparation from nearly all his finished drawings. The surviving studies are revealing. They show that he had no need of preliminary sketches. All he did was vaguely to suggest, with a ram-

*Sir William Rothenstein says that he worked in Beardsley's studio on the opposite side of a large table, but he gives no description of Beardsley's procedure.

bling line, the general disposition of the figures; on top of this he then drew with finality and precision. Those of his finished drawings on which the underdrawing has not been completely rubbed out show the same procedure.

The superb cover design for *Salome* (pl. 16), shows even more clearly how his ideas came to him immediately, with full force. This is as we should expect. He was essentially a visionary and an ideal artist. His early sketches of casual appearances, of which, unfortunately, a number were published after his death, are worthless. No artist, not even Blake, had so little gift for notation. He drew lines round his thoughts. The extraordinary thing is how accurately he could delineate the physical world once it had reformed itself in his memory as a concept. The implied drawing in his figures is always convincing. When, from voluminous skirts, there finally emerges an ankle it is always in the right place. His necks, hands, and arms are drawn as exquisitely as they are on Greek vases, or in Gothic illuminations.

More surprising still, in his late illustrations to Juvenal and Aristophanes, where the nude figures are drawn in attitudes of difficult foreshortening and *contrapposto,* there is still the same absolute certainty. Yet Beardsley seems to have had practically no academic training (he went for a time to evening classes at Westminster School of Art) and never drew "from the life"—any more than did Brygos, or Pol de Limbourg, or Nicholas Hilliard; and one is left wondering if the years spent in art schools by young students, although a pleasant distraction, are not a complete waste of time.

Beardsley's inner eye not only provided him with perfectly clear details, but seems instantly to have shown him how a complete visual experience could simplify itself into vital shapes. His cover design for *The Yellow Book* may seem at first no more than a charming decoration, just as Mr. Roy Lichtenstein's pictures may seem to be no more than blowups of strip cartoons. But look at the frills in their relation to the hair and the curtain in the background. They are a piece of design as energetic as any

hard-edge abstraction; and having seen them in this way we suddenly realize that they are not really at all like frills, and that we accept them as such only because of their powerful abstract design. Very occasionally an ordinary visual experience could clarify itself in Beardsley's mind in this way, as in the *Garçons du Café* (pl. 36), where the relationship of area between the napkins and the shirt fronts was perhaps influenced by the work of Félix Vallotton. But usually this transformation takes place only on behalf of one of the regular inhabitants of his imagination. A masterpiece of this kind is a drawing of another fat woman (pl. 26), less intelligently evil than Mrs. Marsuple—said to be a caricature of Mrs. Whistler—seated at a café table. The consonance and basic completeness of these shapes is superb.

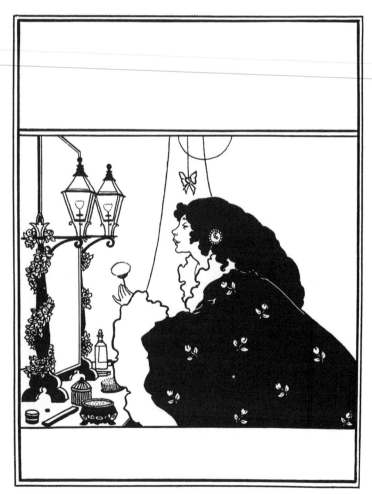

Aubrey Beardsley. Design for the front cover of *The Yellow Book*, Volume III. 1894

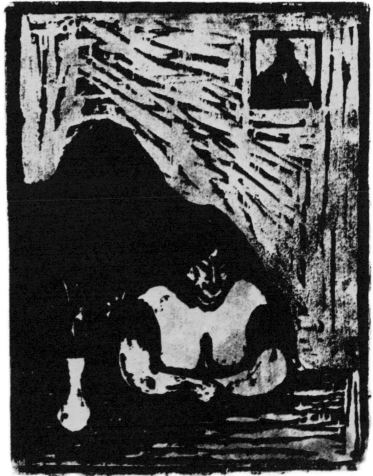

Edward Munch. *The Fat Whore*. 1899

Beardsley's contemporaries, eager to belittle him, used to say that he was a mere eclectic whose style was made up of borrowings from the Japanese, the Greeks, Botticelli, and the Poliphilo. Of course all very young artists must learn where they can; and what his critics really meant was that instead of imitating some noted art teacher of the day, he had gone back to earlier models. (I have heard the head of an art school complaining that his pupils go to the National Gallery, which means that they will imitate Botticelli or Rembrandt instead of imitating him.) As a matter of fact, Beardsley's assimilation of his models was unusually complete. His style has no analogue and points forward, not backward, forward even to Braque, whose painting in the Duncan Phillips' collection of a fat white pot so strangely resembles Beardsley's fat lady.

The Fat Woman is in the Tate, and a sight of the original shows us how

33

shockingly Beardsley's work has been betrayed by reproduction. His work is known almost entirely from line blocks, which have become so much the standard popular image of a Beardsley that critics have said that he adopted his peculiar style in order to please the blockmakers. In fact most of his designs are not in pure black and white, but are tinted or colored so that they achieve a subtle effect of tone, and all the early ones contain lines and dots so delicate that they are lost in anything but a full-size photograph. A drawing like this is difficult even to photograph and must have driven the blockmakers to despair. In fact, they gave up—they heightened tones, coarsened lines, and sometimes redrew passages which were too subtle for them.

The drawings for *Salome* and *The Yellow Book* spread Beardsley's influence throughout Europe. They were reproduced in German art magazines almost immediately, were known to Edvard Munch (then living in Berlin), and showed him how simplified areas of black and white can work on the emotions. They are (with Gauguin) the basis of his magnificent prints. They were reproduced in the Barcelona art magazine *Joventut* in 1898 and inspired the avant-garde of Catalan architects and painters, one of whom later made good use of Beardsley's pure outlines, even doing his own version of *Salome* in which thin, corrupt people are contrasted with fat ones.

In 1900, Beardsley's drawings were reproduced in *Mir Iskusstva*, the art magazine edited by Diaghilev, and had such an effect on Léon Bakst that one may say they are the foundation of the whole Russian ballet style from *Schéhérazade* to *Aurora's Wedding*. What could be more Bakstian than this drawing which Beardsley, in a paradox which turned out to be prophetic, had entitled *A Suggested Reform in Ballet Costume* (pl. 47). The innumerable repercussions on minor artists in Munich, Vienna, Stockholm, and Glasgow need not concern us. Some day they can become the subject of a doctoral thesis.

Lane's telegram of dismissal arrived in April, 1895. It not only caused Beardsley mental and moral distress, but left him without an income. He

Pablo Picasso. *Salome*. 1905.

was rescued by the intervention of a character named Leonard Smithers. Smithers was a small drunken Yorkshireman with no literary or artistic pretensions, but he was before his time in seeing that money could be made out of high-class pornography, and he thought that Beardsley might be a profitable investment. I may add that he behaved admirably to Beardsley and never let him down, even when Beardsley was too ill to work, and Smithers himself was short of cash. It is sometimes said that Beardsley would never have done any indecent drawings if it had not been for Smithers, but personally I doubt this, because he enjoyed shocking

people—as who wouldn't have done in Victorian England; and as his vital spirits began to sink he had to shock himself.

His devotion to evil, although serious enough, was without the priestly earnestness of Baudelaire. When in the mood he could be frivolous about anything, even about art and sin. He adored Poussin, but could not resist giving his own interpretation of *Et in Arcadia Ego,* in which an aging roué in frock coat and spats tiptoes toward the storied urn. As with *Incipit Vita Nova*, the solemnity of these quotations, or rather the pious self-importance of those who quoted them, irritated him. A similar feeling of mischief appears in the demure and fastidious economy with which he has treated a Swinburnian exercise, much respected by more serious decadents (see pl. 43). The most extreme example of this desire to shock is a beautiful drawing of *The Yellow Book* period called *The Mysterious Rose Garden* (pl. 40), which is an impious parody of an Annunciation. Beardsley himself referred to it as the first of a series of illustrations to the Bible. The flat, virginal body is contrasted with the flame-fretted robe of the corrupter and the black lantern, which in some mysterious way gives an impression of light, is itself a strangely evil shape and promises to illuminate the darkest experiences.

Whether at the instigation of Smithers, or in reaction against the outburst of hypocrisy which followed the tidal wave of Wilde's trial, Beardsley set about illustrating *The Lysistrata of Aristophanes.* He wrote that these were in some ways the best drawings he ever did, and no doubt they show an even more masterly control of pure outline. The way in which gross indecency is combined with an austere classical simplicity is worthy of the text. But the omission of contrasted areas of black seems to me a serious loss. Curiously enough these indecencies lack the erotic impact of his *Salome* drawings, either because Beardsley felt it to be unsuitable to Aristophanes, or because this had gained some of its force from repression and concealment. In fact the succession of penises in gigantic erection, with which the Lacedaemonian ambassadors seek to influence the followers of Lysistrata is positively boring.

The style of these drawings can be seen in an unfinished study of Apollo pursuing Daphne (pl. 56). The line is bolder and more comprehensive than in *The Yellow Book* drawings and, except for a few dots, the finicky mannerisms of the *Salome* period have vanished. In the two remaining years of his life, Beardsley was to do a few more austere drawings in this style, in particular some superb illustrations to Juvenal. Unfortunately these too are unpublishable. In contrast to the cheerful ribaldry of *Lysistrata,* they are cruelly indecent and (as I have said) are the only part of his work which can be accurately described as satire. They show how deeply Beardsley entered into the spirit of the authors whose books he illustrated.

Meanwhile he had developed a different style which was to prove more acceptable to his contemporaries and was often claimed as a sort of justification of his whole career. This style first appears in a series of illustrations to Pope's *The Rape of the Lock,* which was published by Smithers in 1896. Beardsley had always loved the eighteenth century, and he took infinite pains to translate the engravings of Nicolas Cochin *père* and Philibert Louis Debucourt into his own idiom. No doubt there was also a technical reason for this change of style. He had temporarily exhausted the effects he could achieve by balancing areas of black and white with patches of ornament. He wished to master a greater variety of tone and texture and even a certain degree of depth.

We can see what was in his mind by comparing one of the best-known *Yellow Book* drawings, *La Dame aux Camélias* (pl. 25), with an analogous drawing in *The Rape of the Lock* (pl. 48). No doubt he has extended his range, but at great cost. For one thing, by abandoning contemporary costume he has lost the impetus which, as Baudelaire so rightly pointed out in his famous article on Constantin Guys, an artist derives from the style of his period. This fashion for painting scenes of another epoch— fancy-dress pictures—weakened the art of the most gifted Victorian painters from Leslie to Orchardson.

If one turns from Beardsley's elaborate construction to slightly earlier

designs which must have taken a tenth of the time, one finds in them a vitality of shape which I have compared with hard-edge abstraction—a quality which *The Rape of the Lock* drawings almost entirely lack. There is a more serious loss, which lies in the very nature of the commission. *The Rape of the Lock* is a masterpiece of wit, elegance, and style, but it allowed Beardsley no opportunity to express his more intense feelings. His drawings are perfect illustrations (see pl. 49), but they are no longer visions, with that quality of obsession which made me compare the *Salome* drawings to Blake. Even in a drawing rather earlier than *Salome, The Kiss of Judas* (pl. 15), there is an intensity which the eighteenth-century pastiches lack.

But when all is said, the illustrations to *The Rape of the Lock* are done with extraordinary wit and technical skill. By their laborious use of line they often achieve a balance of grays as perfect as the earlier balance of absolute black and white. Perhaps one reason why I find them less interesting than *The Yellow Book* drawings is purely accidental—that the eighteenth century which they depict has sunk from being the dreamland of the last romantics, Charles Conder or Ernest Dowson, and become the dreamland of advertising men, which it remained up to the 1940s. Perhaps Kandinsky in 1908–10 was the last creative artist to draw a dividend from the crinolines and towering *chevelures* which had so much delighted Beardsley.

In the autumn of 1895, Smithers prepared a publication to overhaul *The Yellow Book,* which since Beardsley's dismissal had gone into a gratifying decline. It was called *The Savoy,* and appeared in January, 1896. Beardsley did the cover of the first volume (pl. 57). The *amorino* is relieving himself on a copy of *The Yellow Book,* a detail omitted when the drawing was published. It is not a very interesting piece of design, and the subsequent covers or frontispieces are worse. Like all Beardsley's later drawings, they are no longer shocking. It is as if he had been deserted by the powers of evil which had been his inspiration. The editor of *The Savoy* was Arthur Symons, who had a keener eye for quality and intelligence

than Henry Harland, and the literary side is excellent. Beardsley was art editor but, as he was not at all interested in contemporary painting, the only art contents of any merit, other than some graceful drawings by Charles Shannon, were the work of Beardsley himself; and these are by no means all of them satisfactory. Not that they are bad compared to the work of his imitators, whose work appeared in *The Savoy* and in every art magazine in Europe. But there is a loss of intensity, due as much to failing health as failing vision; and the discovery of abstract shapes, which brings the earlier drawings so close to us, is almost entirely absent.

An exception, done, it is true, a little earlier, is *The Return of Tannhäuser to the Venusberg* (pl. 44), which is a developed version of a drawing which must date from his teens. This was a naïve piece of Pre-Raphaelitism, but it had the visionary conviction of the adolescent which Beardsley has managed to preserve. Three of the *Savoy* drawings were inspired by Wagner and show how, from Baudelaire to Schoenberg, that vast unpleasant genius loomed over the romantic imagination. Beardsley was particularly attracted to Wagner's Loge, whom he made the subject of two extraordinary drawings and a description in *Under the Hill.*

I must confess that these illustrations to the *Rheingold* make me feel uneasy; but so does the *Rheingold,* and there is no doubt about the skill with which Beardsley has translated its swirling, flickering movement. The rhythms of Art Nouveau, which for the last time appear in his work, seem all too appropriate.

In the literary milieu of *The Savoy,* Beardsley also became a writer, and several of his pieces were published with illustrations. One of them, a poem called "The Ballad of a Barber," was fully equal to the work of the minor poets who surrounded him, and was accompanied by an exquisite drawing (pl. 52), one of the few which succeeds without help from the powers of evil. How did an untrained youth achieve this masterly composition in which every movement in the pyramid, from the tassel of the footstool to the little statuette of the Virgin and Child, is surprising, inevitable, and lyrically sustained?

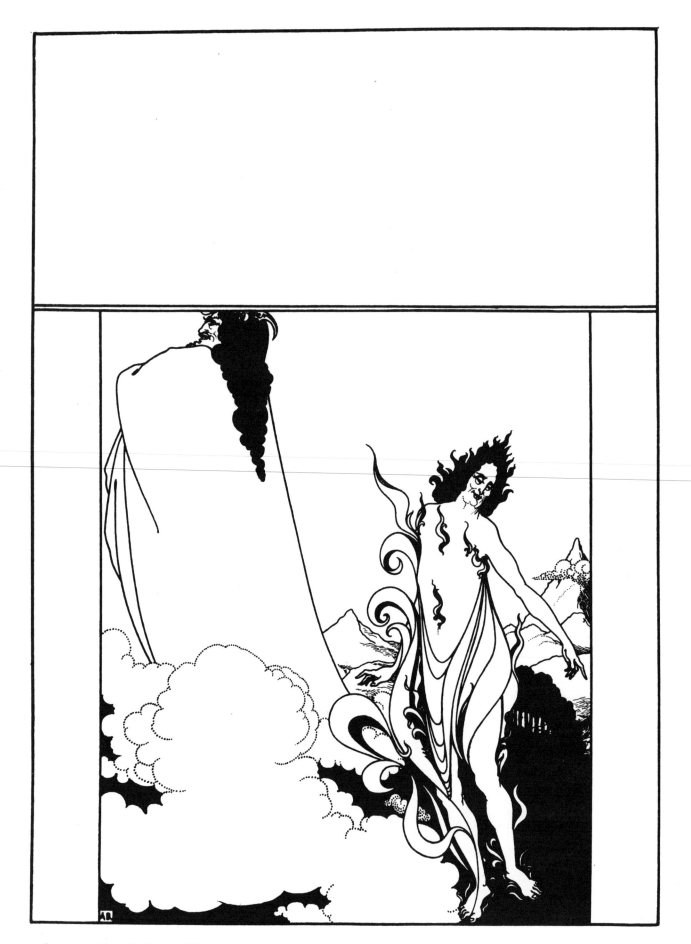

Aubrey Beardsley. The Fourth Tableau of 'Das Rheingold.' Design for the front wrapper of *The Savoy*, no. 6. 1896

His longest piece of writing was in prose, a so-called romantic novel entitled *Under the Hill*. It is an expurgated version of an extremely indecent original, *The Story of Venus and Tannhäuser*, which he seems to have written to console himself immediately after he was sacked from *The Yellow Book* and which remained in manuscript during his lifetime. This, too, was illustrated, and Beardsley, with his usual love of teasing, put his Venus (who had such surprising adventures) into a chastely shapeless garment, looking as if butter wouldn't melt in her mouth. The elaborate prose style of *The Story of Venus and Tannhäuser* has been praised by good judges from Arthur Symons onward; but I find it absurd. At best it could be claimed as a sort of link between William Beckford and Ronald Firbank.

The first illustration represents Tannhäuser, renamed the Abbé Fanfreluche (pl. 50); in an intermediate draft of the manuscript he is called the Abbé Aubrey. When one considers that Beardsley was twenty-three years old and dying of consumption, the drawing is a moving act of defiance. The fourth chapter of *Under the Hill*, in which the Abbé wakes up in bed, fresh as a daisy after his debauch, is indeed an undisguised piece of autobiography, a literary sequel to the earlier drawing of himself in bed in *The Yellow Book* (pl. 37).

Fanfreluche awoke, stretched himself deliciously in his great plumed four-post bed, murmured "What a pretty room!" and freshened the frilled silk pillows behind him. . . . Then he lay back in his bed, stared at the curious patterned canopy above him and nursed his waking thoughts.

He thought of the "Romaunt de la Rose," beautiful, but all too brief.

Of the Claude in Lady Delaware's collection.

Of a wonderful pair of blonde trousers he would get Madame Belleville to make for him.

Of a mysterious park full of faint echoes and romantic sounds.
. . .

Of Saint Rose, the well-known Peruvian virgin; . . . of the splendid opening of Racine's "Britannicus." . . .

Of Morales' Madonnas with their high egg-shaped creamy foreheads and well-crimped silken hair.

Of Rossini's "Stabat Mater" (that delightful *demodé* piece of decadence, with a quality in its music like the bloom upon wax fruit).

Of love, and of a hundred other things.

Such were the waking thoughts of a boy who knew that he had only a year to live. Indeed friends who visited him during the summer of 1896 doubted if it would be as long. In March, 1897, he was received into the Catholic church. Immediately afterward his health improved, he moved to Paris and later to Dieppe, that vanished paradise of poets and artists of the 1890s; then back to Paris, where he stayed until the cold weather became too much for his lungs. During this year he did a few illustrations to Théophile Gautier's *Mademoiselle de Maupin,* which suggest that the falling off of *The Savoy* drawings was only a phase. One of them, of his favorite subject, a lady at a dressing table, is a masterpiece (pl. 59). In it he returns to the use of tone in the first *Studio* drawings, but with an entirely new sense of space. From here he might have gone anywhere.

In November he moved to Menton, which delighted him. His sole interest was an edition of *Volpone,* for which he did a prospectus (later used as a frontispiece), a set of initials in a new style, and a cover like a Jackson Pollock (pl. 61). He was afraid that Smithers, who had taken to the bottle, would somehow let him down; and it is true that the *Volpone,* which appeared after his death, is (apart from the cover) a poor piece of book production, printed on shiny paper which, as Beardsley said, emphasizes a certain coldness in his frontispiece. The drawing of Volpone

himself (pl. 62) shows no falling off in power of design, and as illustration it is the very essence of Ben Jonson's fox.

In January the weather at Menton changed, and Beardsley was confined to the pretty room which his mother had made so comfortable for him. A photograph shows him seated in it, as alert and *soigné* as ever: the wall covered with facsimiles of Mantegna's engravings and in front of them a crucifix. This room he was never to leave. Having received the last sacraments, he died on March 16, 1898, aged twenty-five years and seven months. His grave is in the beautiful cemetery overlooking the old town, and ten years ago was so overgrown as to be invisible. As everyone knows, he wrote on his deathbed to Smithers entreating him to destroy all editions of *Lysistrata* and his other indecent drawings. This was not done. *The Story of Venus and Tannhäuser* was printed in 1907; and, although Beardsley is almost forgotten as an artist, he is still in demand among booksellers dealing in curiosa.

Oscar Wilde, whom he had treated with disdain, wrote to Smithers, with his usual generosity, "I am greatly shocked to read of poor Aubrey's death. Superbly premature as the flowering of his genius was, he still had immense powers of development, and had not sounded his last stop. There were great possibilities always in the cavern of his soul." Anyone who looks carefully at Beardsley's best work will agree. But this was not the current contemporary opinion. A writer named M. C. Marillier, who was selected by John Lane to present the first collection of Beardsley's work, ended his introduction with these patronizing words: "Poor Beardsley! His death has removed a quaint and amiable personality from amongst us; a butterfly who played at being serious, and yet a busy worker who played at being a butterfly."

Such, in 1899, was the response of what Bernard Berenson used to call the "art-hating Angry-Saxons" to the only English artist of his time who had the slightest reputation or influence in Europe. But Julius Meier-

Graefe, in his *Modern Art,* that pioneer work which, for the first time, saw the movement as a whole and in relation to the past, spoke of Beardsley in a very different tone: "Not until we have learnt to understand Beardsley or Dostoyevski or Manet as we understand Bismarck, shall we reach the stage of culture." This may be slightly obscure, but he adds apropos of Beardsley, a sentence which throws light on it. "Our utilitarianism was never rebuked in stronger or haughtier terms." No doubt that this great critic, who knew him personally, regarded him as one of the essential men of genius of his time.

Genius. Almost everyone who met Beardsley committed himself to this questionable word and made claims for his art which seem to us extravagant. But genius it was, that immediate access to some world outside our own, that perfectly clear conviction, which creates its own skill, that a thing must be thus and thus and not otherwise. It is something easily distinguished from talent or from other admirable qualities: and it is not so common that we can afford to forget it.

The Plates

Tannhäuser

Rightly described by Brian Reade as an "amateur drawing," this is nevertheless a precious indication of Beardsley's spirit. It is extraordinary that the idea of repentance and return was already in his mind at the age of nineteen. He returned frequently to the subject of Tannhäuser and developed the same pictorial idea in one of his finest drawings, done in 1896 (see pl. 44).

1891
Indian ink and wash, 6¾ × 6¾"
National Gallery of Art, Washington, D.C. Rosenwald Collection

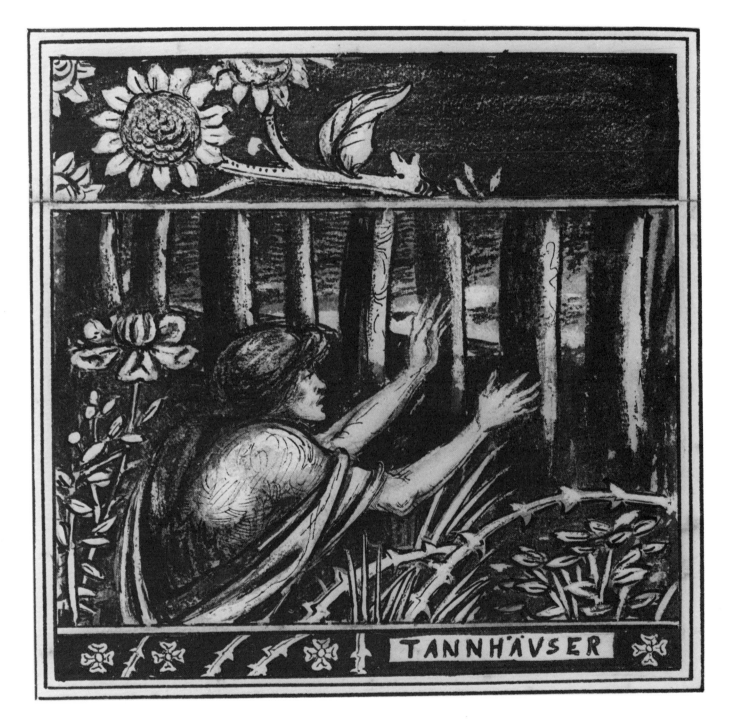

PLATE I

The Litany of Mary Magdalen

This is Beardsley's first great drawing and, as so often happens with artists, it foreshadows much of his later work. It was done immediately after his visit to Burne-Jones in 1891, and the figure on the right is obviously derived from him. On the other hand, the man in the center is inspired by Mantegna's engraving of the Entombment, from which he also derived the figure of the kneeling Magdalen. The engraving can be seen on the wall of the room in Menton in which Beardsley died.

He returned to the same theme in a pen-and-ink drawing in Volume IV of *The Yellow Book* called *The Repentance of Mrs.* Like all artists in search of the ideal, Beardsley often repeated the same subjects, with minimal variation: *The Return of Tannhäuser to the Venusberg* (pl. 44) is an example. In each case the subject revealed his deepest feelings—the need for repentance and return.

1891
Pencil, 8 × 6"
Courtesy of The Art Institute of Chicago

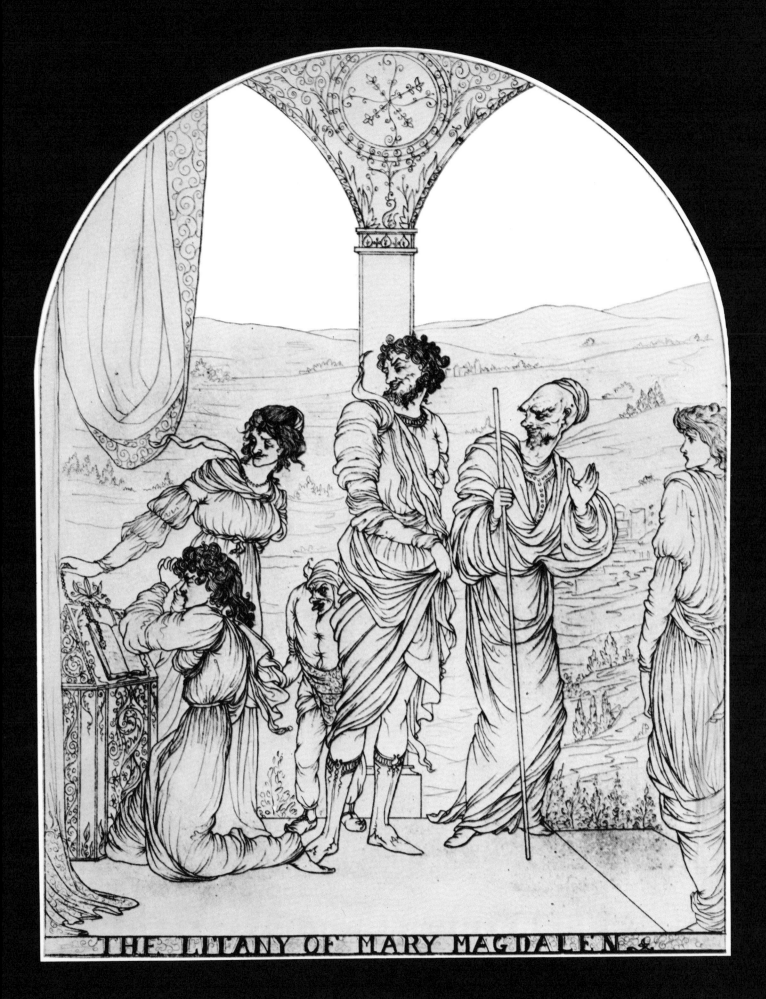

THE LITANY OF MARY MAGDALEN

PLATE 2

Les Revenants de Musique

This is the quintessence of harmless aestheticism and as such seems to us rather ridiculous. But looked at sympathetically it is rather beautiful, and one can see how it gave Lewis Hind a feeling of false security, which was dispelled by the drawing which followed it in *The Studio, J'ai baisé ta bouche Iokanaan* (pl. 13).

Illustration in *The Studio,* no. 1
April 1893
Reproduced from the line block

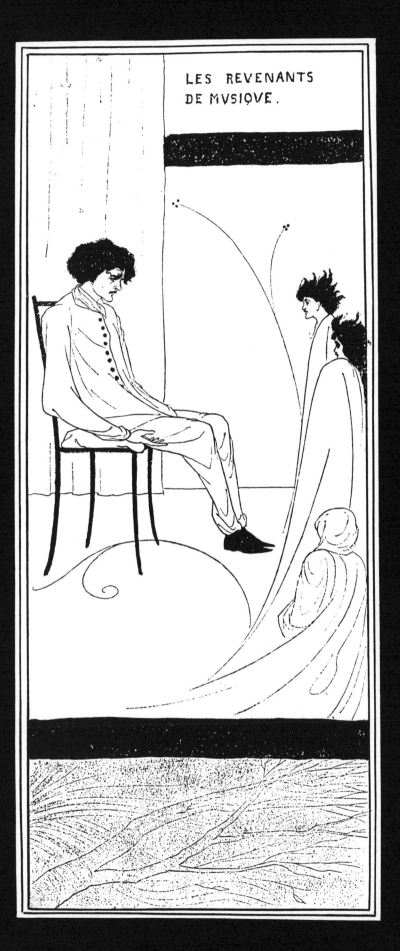

LES REVENANTS
DE MVSIQVE.

PLATE 3

How King Arthur Saw the Questing Beast

This drawing was used as the frontispiece to Volume I of *Le Morte Darthur.* It is in an elaborate style, totally unlike the black-and white decorations in the rest of the book; but a similar drawing, *The Achieving of the Sangreal,* was used as the frontispiece to Volume II. They are out of keeping with the rest of the book, and it is hard to know why Beardsley let them in. There is an almost invisible signature at the bottom of the trees and the date March 8, 1893. This means that it was done fairly late in the progress of the three volumes. It anticipates drawings like the *Siegfried* (pl. 11), but is less satisfactory because Beardsley has put in a profusion of motifs and has covered every area with spidery lines that are meaningless and tiresome. But the intensity of Arthur's head points forward to the *Salome* drawings.

Drawing for the frontispiece to VOLUME I of Malory's
Le Morte Darthur
1893–94
Pen, ink, and wash, 14 × 10⅝"
Victoria and Albert Museum, London. Harari Bequest

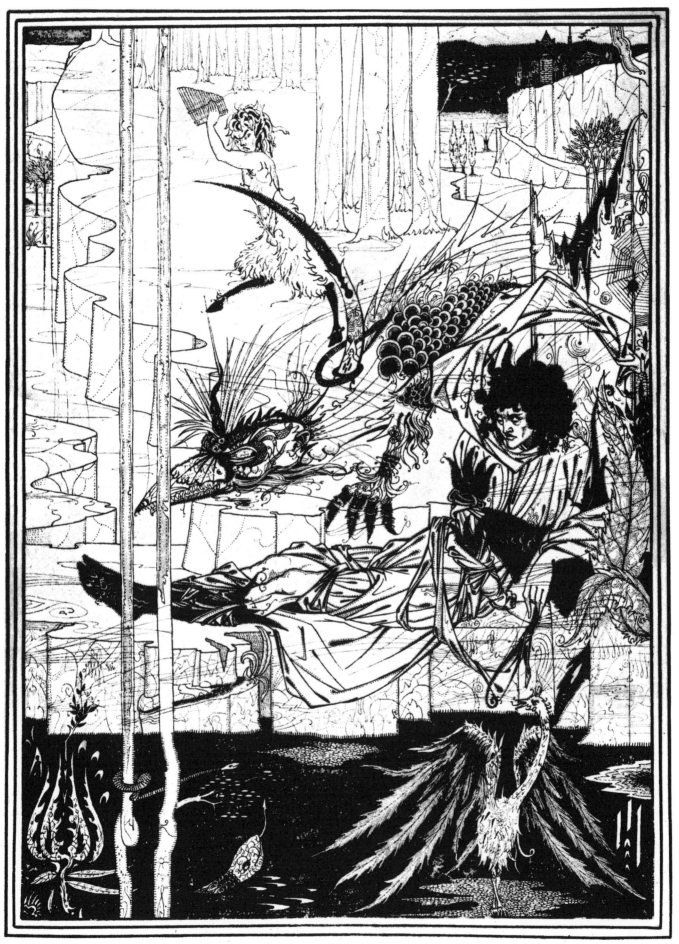

PLATE 4

Border and initial A with the opening
text of VOLUME I,
Chapter I, Book II of *Le Morte Darthur*

An example of Beardsley's amazing virtuosity at
the age of twenty-one. Into the vegetable border
in the William Morris style, he has inserted six
satyresses who climb about the spikey tendrils in
every kind of attitude. The vigor and resource of
this border are in contrast to the delicate economy
of the border in plate 9 and show that the young
Beardsley could do anything.

1893–94
Reproduced from the line block
Courtesy of New York Public Library

Book ij. Chapter j.

OF A DAMOSEL WHICH CAME GIRT WITH
A SWORD FOR TO FIND A MAN OF SUCH
VIRTUE TO DRAW IT OUT OF THE SCABBARD.

 FTER the death of Uther Pendragon reigned Arthur his son, the which had great war in his days for to get all England into his hand. For there were many kings within the realm of England, and in Wales, Scotland, and Cornwall. So it befell on a time when King Arthur was at London, there came a knight and told the king tidings how that the King Rience of North Wales had reared a great number of people, and were entered into the land, and burnt and slew the king's true liege people. If this be true, said Arthur, it were great shame unto mine estate but that he were mightily withstood. It is truth, said the knight, for I saw the host myself. Well, said the king, let make a cry, that all the lords, knights, and

PLATE 5

How La Beale Isoud Nursed
Sir Tristram

It is interesting to find already in *Le Morte Darthur,* with its reminiscence of William Morris's rich, ornamental style, a drawing which foreshadows the extreme severity of Beardsley's later style. The figures, framed in straight horizontal lines and near-straight verticals, are themselves of almost geometrical simplicity. The border is, for once, not composed of swirling lines. This austerity and the guttering candlestick (as in *Enter Herodias*; pl. 23) lead me to guess that this was one of the last of the *Morte Darthur* drawings to be completed. It is certainly one of the finest.

Drawing for an illustration in VOLUME I,
Chapter IX, Book VIII of *Le Morte Darthur*
1893–94
Pen and ink, 11 × 8¾"
*Fogg Art Museum, Harvard University,
Cambridge, Mass. Scofield Thayer Collection*

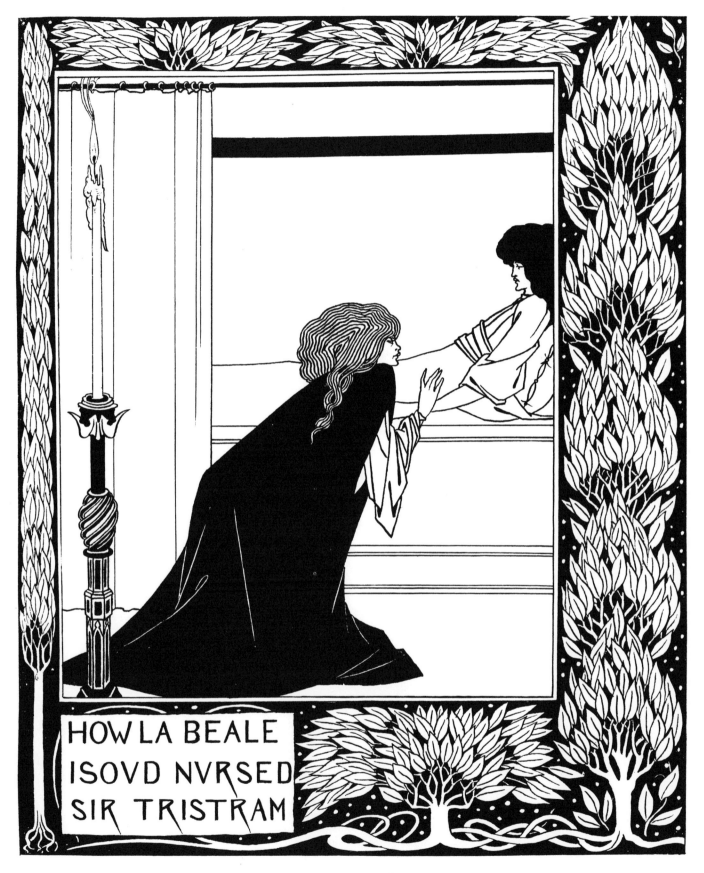

HOW LA BEALE
ISOVD NVRSED
SIR TRISTRAM

PLATE 6

Two chapter headings of
Le Morte Darthur

Although one may feel, in glancing through the three volumes of *Le Morte Darthur,* that there are too many chapter headings, they are amazingly inventive and maintain a high level of intensity. Many of them avoid the Pre-Raphaelite romanticism of the whole-page drawings and are really a record of Beardsley finding himself. They suggest that there were far more ideas in his mind, both pictural and emotional, than ever found expression.

1893–94
Reproduced from the line blocks

PLATE 7

PLATE 7 A

How La Beale Isoud Wrote
to Sir Tristram

To date the *Morte Darthur* drawings on stylistic grounds would be a lengthy, inconclusive task. But this, although it appears in the first volume, would seem to be one of the latest. It shows a sense of space rare in his early work; and the geometric lines of La Beale Isoud's cloak anticipate drawings like *The Spinster's Scrip* (pl. 42). The huge black *chevelure* is said by Brian Reade to have been originally linear, but this would have been much less effective. It is typical of Beardsley's skill that he should have balanced the black and white of the figure with the windows made from the bottoms of glasses, a favorite architectural device of Art Nouveau.

Drawing for an illustration in VOLUME I,
Chapter X, Book IX of *Le Morte Darthur*
1893–94
Pen and ink, $10^{13}/_{16} \times 8^{7}/_{16}''$
Private collection, England

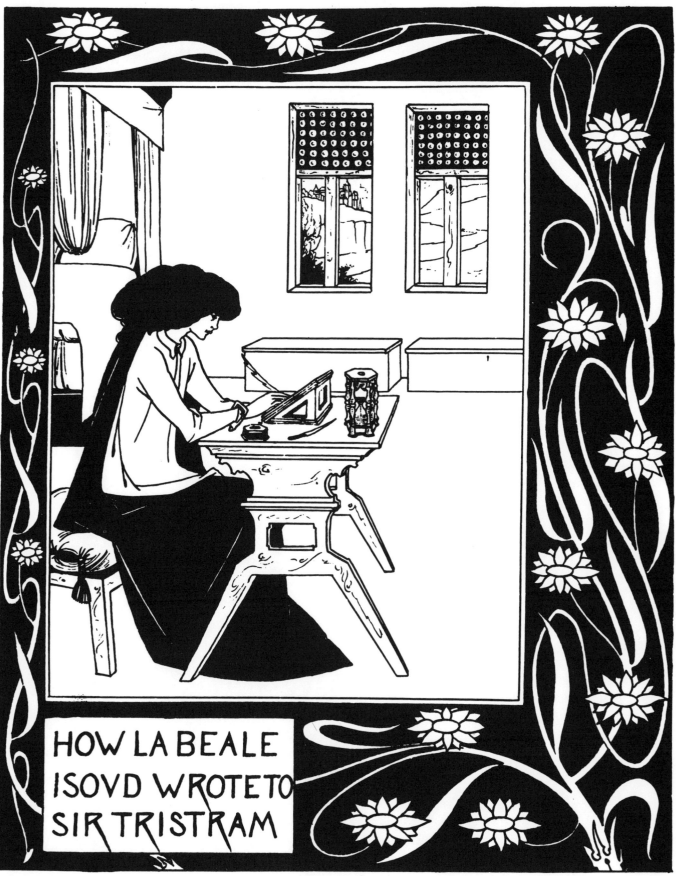

HOW LA BEALE
ISOVD WROTETO
SIR TRISTRAM

PLATE 8

Drawing for a full-page border with the initial A of VOLUME II, Chapter I, Book XII of
Le Morte Darthur

One of the few surviving drawings for the pages of *Le Morte Darthur.* There must have been several hundred, and one is left wondering what has become of them because Beardsley's drawings were already much esteemed at that date.

1893–94
Pen and ink, 11 × 8″
Princeton University Library, Princeton, New Jersey

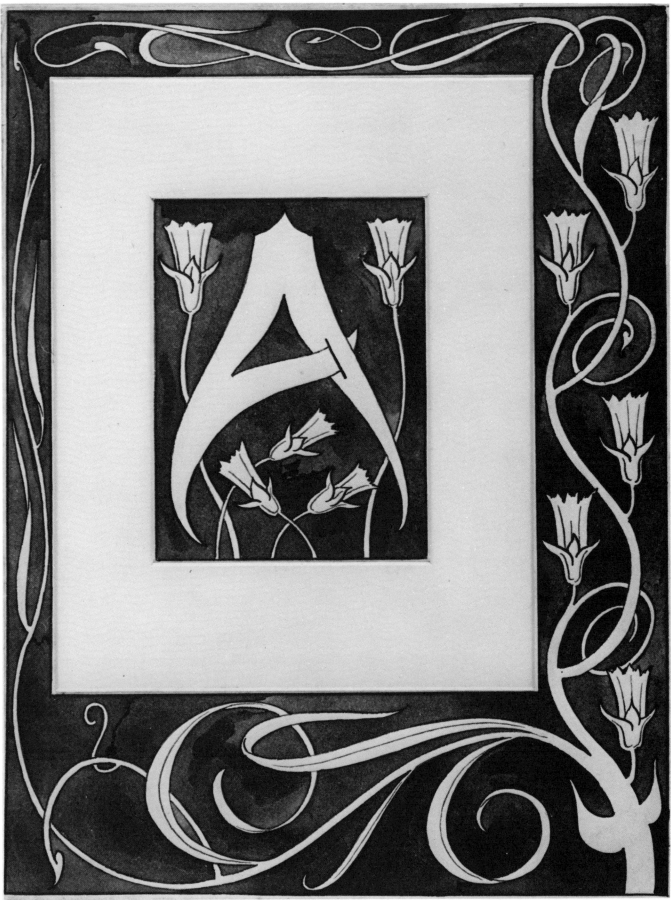

PLATE 9

How Queen Guenever Made Her a Nun

The most famous of the *Morte Darthur* drawings and deservedly so, for the black mass of the queen's cloak standing out against the rich ornamental background is impressive and moving. In contrast to the preceding plate, the border is of great freedom and complexity.

Illustration in VOLUME II, Chapter IX,
Book XXI of *Le Morte Darthur*
1893–94
Reproduced from the line block

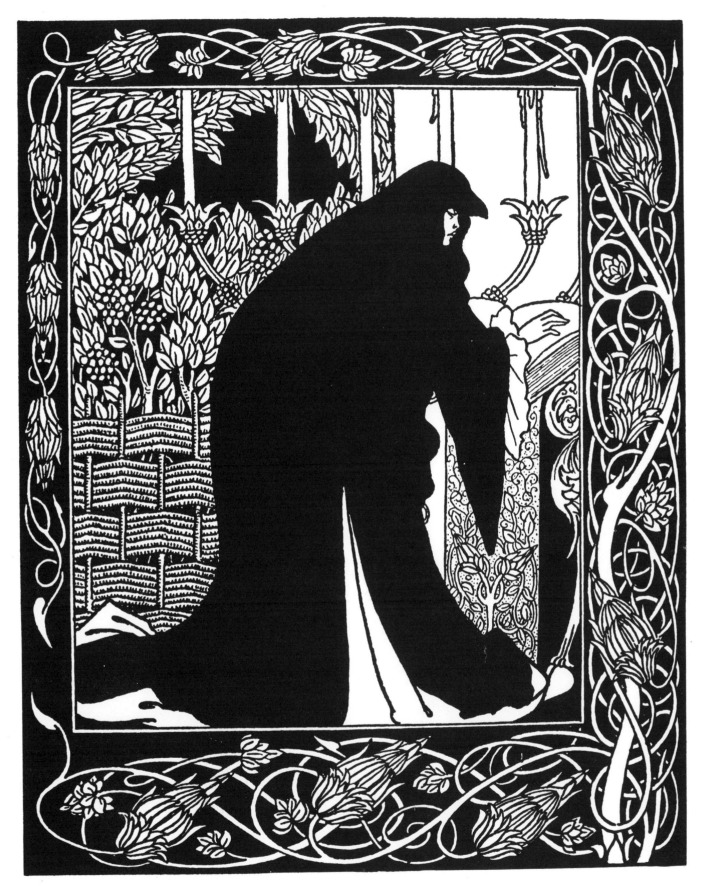

PLATE 10

Siegfried, Act II

In the same over-elaborate manner as the frontispiece to Volume I of *Le Morte Darthur* (see pl. 4), this drawing is a little less charged with detail and so is perhaps the last of the series. The elegantly knock-kneed Siegfried is comically un-Wagnerian, and if, as must be presumed, Beardsley had seen the heavyweights who normally interpret this character, there may have been an element of mischief in depicting him as this effete dandy.

The flowers that grow out of the pool and sprout beside the figure are perhaps the last of Beardsley's decorative fantasies. The distant landscape is obviously inspired by the background of Pollaiuolo's *Martyrdom of St. Sebastian* in the National Gallery in London.

Beardsley gave this drawing to Burne-Jones. After his death Lady Burne-Jones gave it to Beardsley's mother.

Drawing illustrating Wagner's drama
c. 1892–93
Indian ink and wash, 15¾ × 11¼"
Victoria and Albert Museum, London

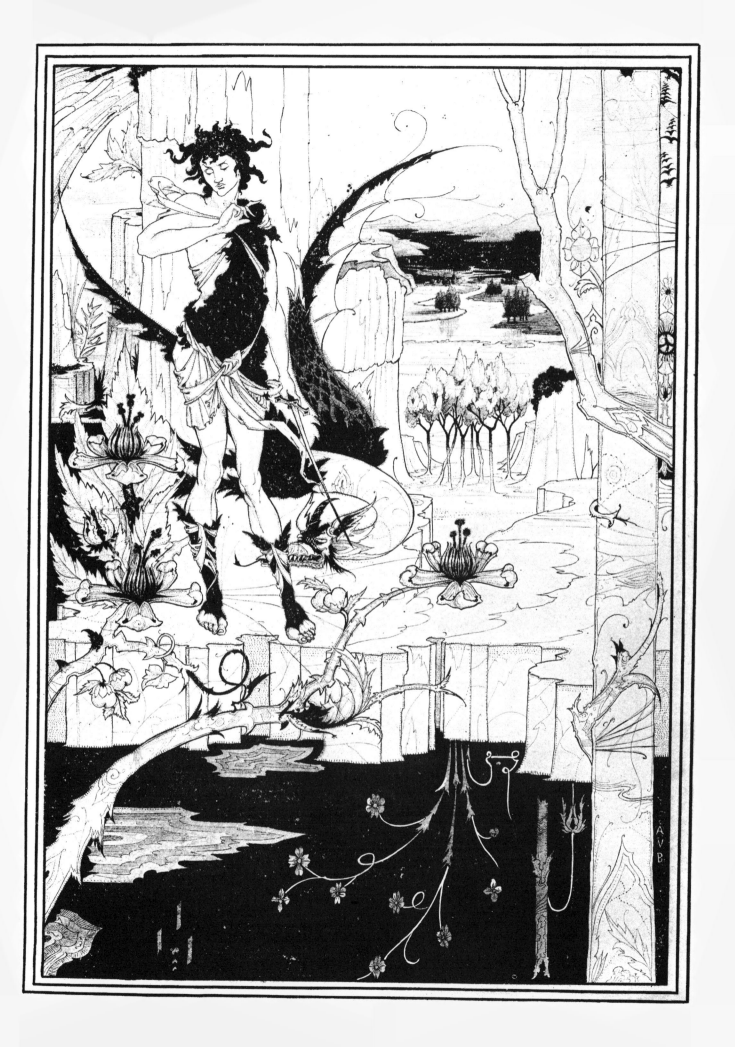

The Birthday of Madame Cigale

Done when he was still at work on the *Morte Darthur* drawings, this is a reaction against them, both in technique and subject. Beardsley was bored by the black and white of the pseudo-William Morris style which Dent had imposed on him, and therefore used a gray background and tinted parts of the drawing with a wash. I have seen this technique described as "a precious gift from the Japanese," but I can think of no Japanese book or print in which it is used. However, there are many other reminiscences of Japanese design of a kind that had been common in decorative art in the preceding fifteen years.

The drawing seems to have been rather hastily compiled from other sources, notably the rather horrid little illustrations that he contributed to a publication entitled *Bons-Mots*. The base makes use of the same motifs as the most elaborate drawing for *Le Morte Darthur —How King Arthur Saw the Questing Beast,* dated March, 1893 (pl. 4). The subject is also somewhat factitious, and no one knows how the name of Madame Cigale entered Beardsley's mind.

Drawing for an illustration in *The Studio,* no. 1
April 1893
Pen, ink, and wash, 9¾ × 15⅛"
*Fogg Art Museum, Harvard University,
Cambridge, Mass. Grenville L. Winthrop Bequest*

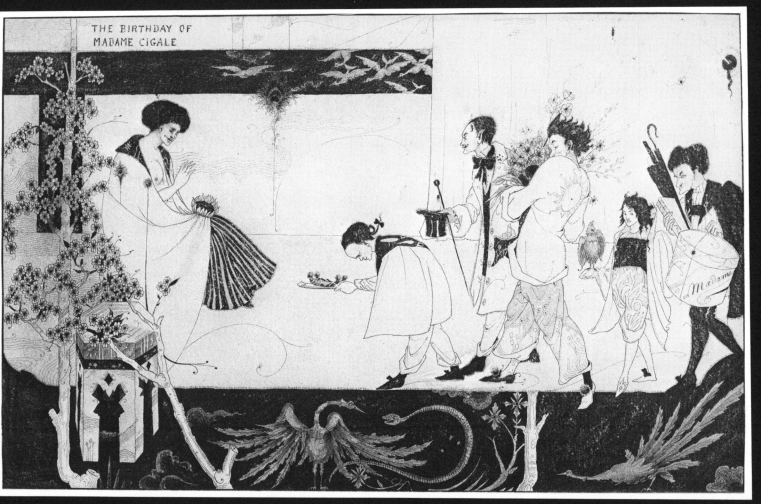

PLATE 12

J'ai baisé ta bouche Iokanaan

When Lewis Hind made Beardsley's drawings the chief feature of his newly founded magazine *The Studio,* he could not have guessed what trouble was in store for him. The drawing of Salome with the severed head of St. John the Baptist aroused more horror and indignation than any graphic work hitherto produced in England, and it is indeed a horrifying work, not only in the subject but in the accompanying concert of evil shapes. The design, with the figures, as so often, at the top of the frame, and the long line of St. John's blood flowing down into a deep pool, is an inspiration.

The point of departure was Oscar Wilde's *Salome,* which Beardsley must have read in French in the first edition. This drawing induced John Lane to commission him to do a series of illustrations to an English edition, which was to be published in 1894. Beardsley repeated the design in a simplified form, but to my mind what is gained in clarity is lost in intensity. It no longer makes one's flesh creep. The ferocious head of Salome has become almost compassionate, and St. John has ceased to be an object of desire.

Drawing for an illustration in *The Studio,* no. 1
April 1893
Ink with green watercolor wash, 11 × 5¹³/₁₆″
Princeton University Library, Princeton, New Jersey

70

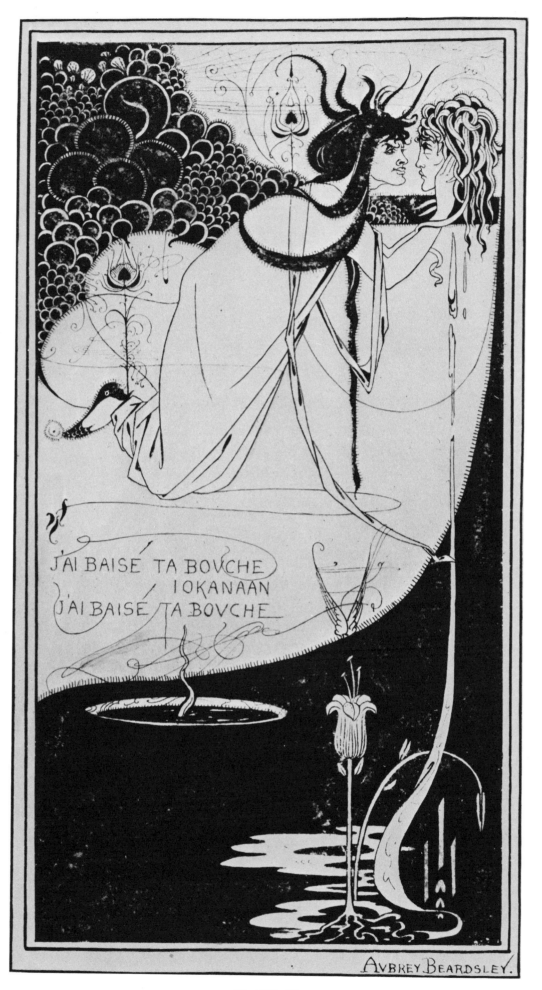

PLATE 13

Incipit Vita Nova

The little monster had appeared already in *Bons-Mots,* but he assumed increasing importance in Beardsley's mind as a symbol of evil and plays a leading part in his most evil drawing, *Enter Herodias* (pl. 23). No doubt he came from the depths of Beardsley's subconscious, and after *Salome* he was dropped. He is usually referred to as a fetus, but I have never seen one, so I cannot say if this is accurate. Brian Reade says, "The foetus with the hydrocephalus head might be said to represent Beardsley's own generation." Much as I admire Brian Reade's comments in general, I just don't agree with it. He is simply some unpleasant sensation in the pit of Beardsley's stomach that he wanted to externalize. To associate him with the first sentence of the *Vita Nova,* that sacred book of Rossetti and his followers, was an act of rebellion against the Pre-Raphaelitism from which Beardsley had emerged and is made more pointed by the fact that the goblin is accompanied by a sort of caricature of a Rossetti woman.

c. 1893
Indian ink and Chinese white on brown paper
$8 \times 7^{13}/_{16}''$

Collection Dr. Nicholas Pickard
Kansas City, Missouri

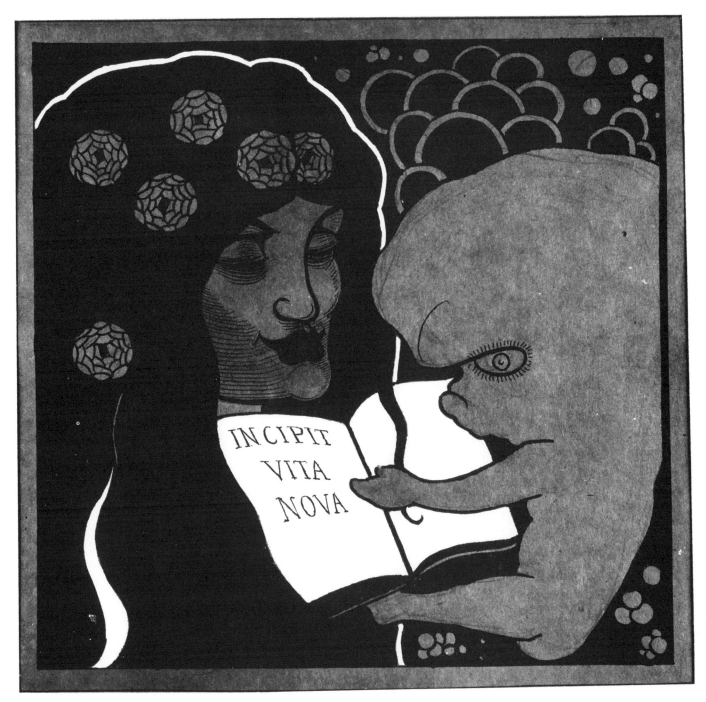

PLATE 14

The Kiss of Judas

The design, based on horizontals of unrelieved black and verticals decorated like espaliers, reappears in one of the *Salome* drawings, *A Platonic Lament*, and they were probably done at the same time. But in *The Kiss of Judas,* Beardsley has followed his more usual practice of pushing the interest up into the top half of the frame. I suggested in the text that, in the relation of the figures to the landscape, Beardsley was thinking of Puvis de Chavannes's *Pauvre Pêcheur,* one of the most original and influential pictures of its time. We know that he met Puvis when he was in Paris. The reclining woman is a beautiful invention (look at her legs and left foot), and it is extraordinary how Beardsley has been able to express so much wickedness in the child's cranium.

The article in *The Pall Mall Magazine,* signed X.L., says that *The Kiss of Judas* is a Moldavian legend. "They say that Children of Judas, lineal descendants of the arch traitor, are prowling about the world seeking to do harm, and that they kill you with a kiss. 'Oh! how delightful!' murmured the Dowager Duchess." That surely is the voice of Beardsley.

Drawing for an illustration in *The Pall Mall Magazine*
July 1893
Pen and ink, 12¼ × 8⅝"
Victoria and Albert Museum, London. Harari Bequest

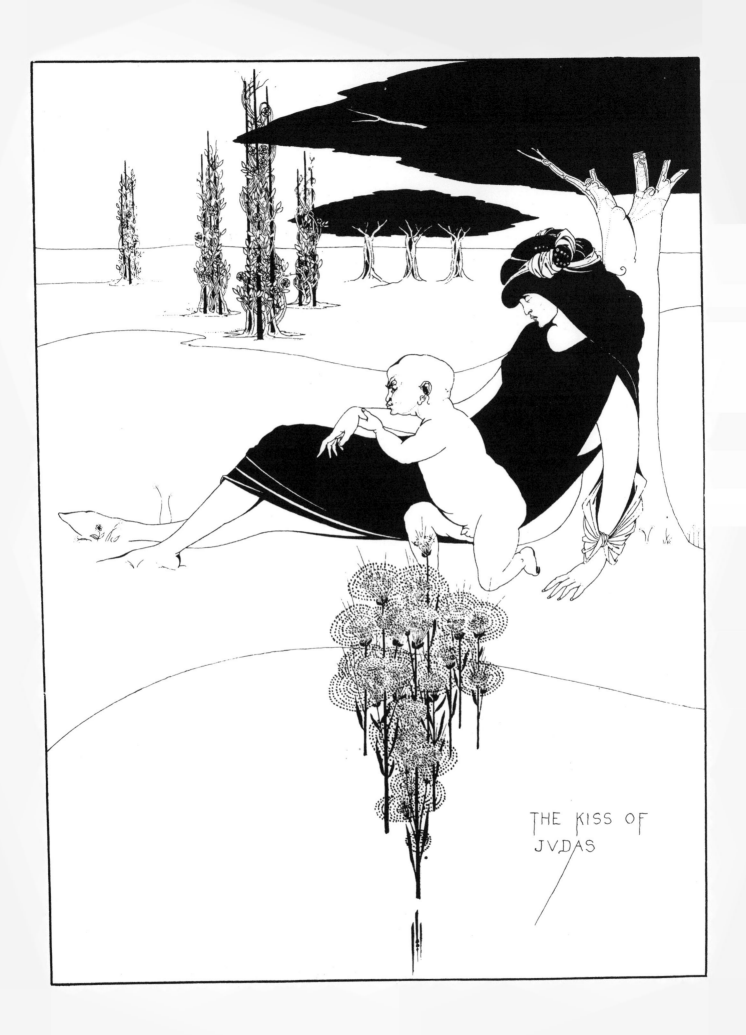

THE KISS OF
JVDAS

Design for the front cover of Wilde's *Salome*

Those who think of Beardsley as a finicky artist should remember this magnificent design. Although based, I suppose, on peacock feathers, these emblems of the period have become the almost unrecognizable expressions of pictorial energy. The design has to me an Islamic character, but I know of no evidence that Beardsley was familiar with Persian art, so the resemblance may be accidental. One wonders how often a similar boldness underlay other drawings which Beardsley then rendered in his usual restrained style. The cover actually used for *Salome* is conventional.

Not used for the edition of 1894 but reproduced in
*A Portfolio of Aubrey Beardsley's Drawings Illustrating
'Salome' by Oscar Wilde*
1907
Reproduced from the half-tone plate
Collection Brian Reade, London

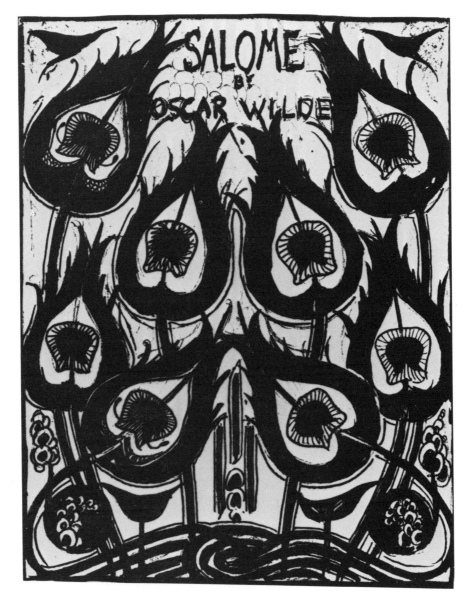

PLATE 16

The Woman in the Moon

One of the most liberated of all Beardsley's drawings. The setting of the two figures has no relation to visual experience and is as abstract as a 1912 Kandinsky. The figures themselves are drawn with unusual sympathy; their heads lack the mischievous expressions that are usual in Beardsley's work. They seem reluctant to enter an incomprehensible world. They are watched with cynical detachment by the Woman in the Moon, whose features were intended as a sort of caricature of Oscar Wilde.

Several of Beardsley's designs—*The Kiss of Judas* (pl. 15), the *Caricature of Whistler* (pl. 29) —push the interest up to the top of the frame, leaving the lower half without incident. Critics have tended to speak of Beardsley's line as if it were his main achievement. In fact his disposition of masses is more important. But *The Woman in the Moon* shows his line at its purest and most delicate. By comparison the line of *Enter Herodias* (pl. 23) is relatively coarse.

Drawing for the frontispiece of *Salome*
1894
Pen and ink, 8¾ × 6⅛"
Fogg Art Museum, Harvard University,
Cambridge, Mass. Grenville L. Winthrop Bequest

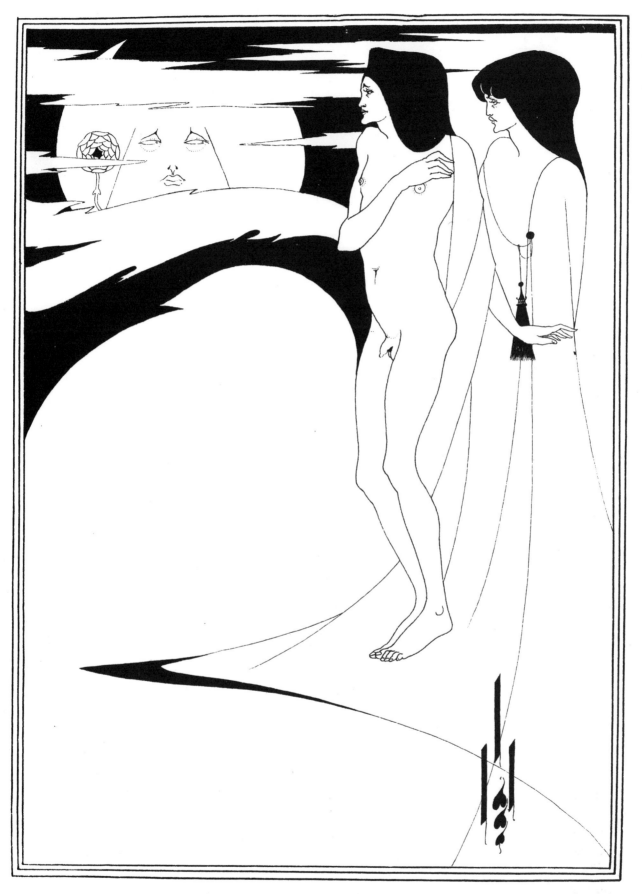

PLATE 17

The Peacock Skirt

This is Beardsley's most complete surrender to the charms of the peacock, which ever since Whistler's famous Peacock Room (1876) had played a conspicuous role in the imagery of the 1890s. He has used the motif brilliantly, but even so the drawing is less original than, say, *The Black Cape* (pl. 19).

As noted in the introduction, Beardsley came to have a low opinion of Wilde. But Wilde, when he heard how ill he was, wrote generously from Reading Gaol, "Poor Aubrey; I hope he will get all right. He brought a strangely new personality to English art, and was a master in his way of fantastic grace, and the charm of the unreal. His muse had moods of terrible laughter. Behind his grotesques there seemed to lurk some curious philosophy." The last sentence is very perceptive.

Drawing for an illustration in *Salome*
1894
Pen and ink, 8⅞ × 6¼″
Fogg Art Museum, Harvard University,
Cambridge, Mass. Grenville L. Winthrop Bequest

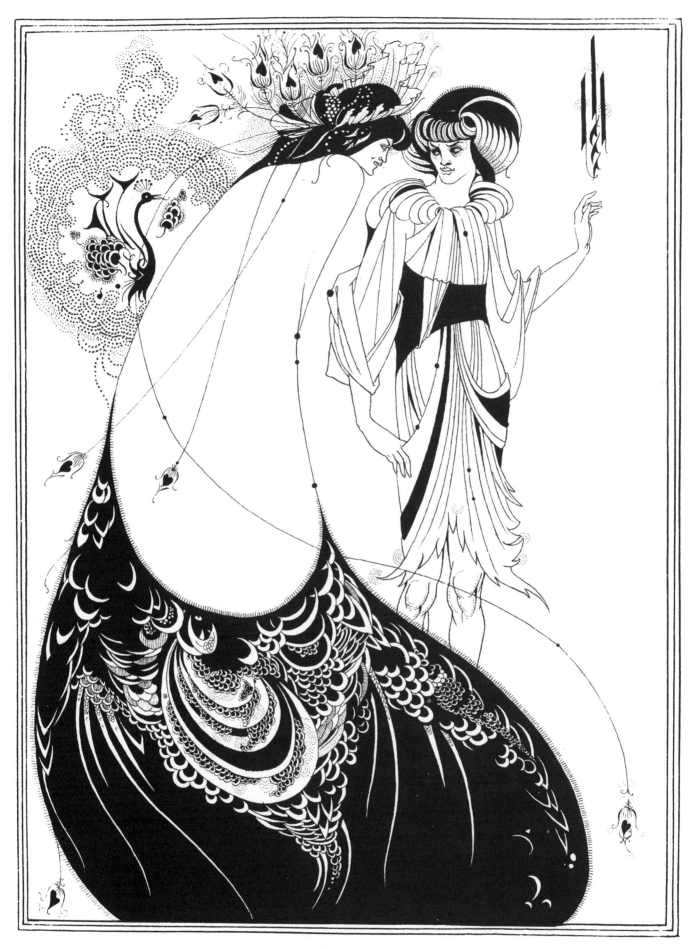

PLATE 18

The Black Cape

Few of Beardsley's drawings more willfully flout the evidence of appearances than this one. As a rule we are conscious of a body underneath his fanciful costumes, but nobody inhabits the black cloak and its incomprehensible skirt, which is as far from reality as the lady's enormous *chevelure*. Her face is unimportant. The drawing is a completely liberated exercise in abstract design, and as such is one of Beardsley's most extraordinary works. It seems to have no connection with Wilde's text and shows how confident in his genius Beardsley had become. The way in which the figure stands alone, displaying her astonishing garment, was probably inspired by a Japanese print. Similar isolated figures appear in the prints of Kiyonaga's followers, in particular Sharaku and Chōki, although Beardsley is more likely to have seen the ubiquitous Kunisada.

Drawing for an illustration in *Salome*
1894
Pen and ink, $8^{13}/_{16} \times 6\frac{1}{4}''$
Princeton University Library, Princeton, New Jersey

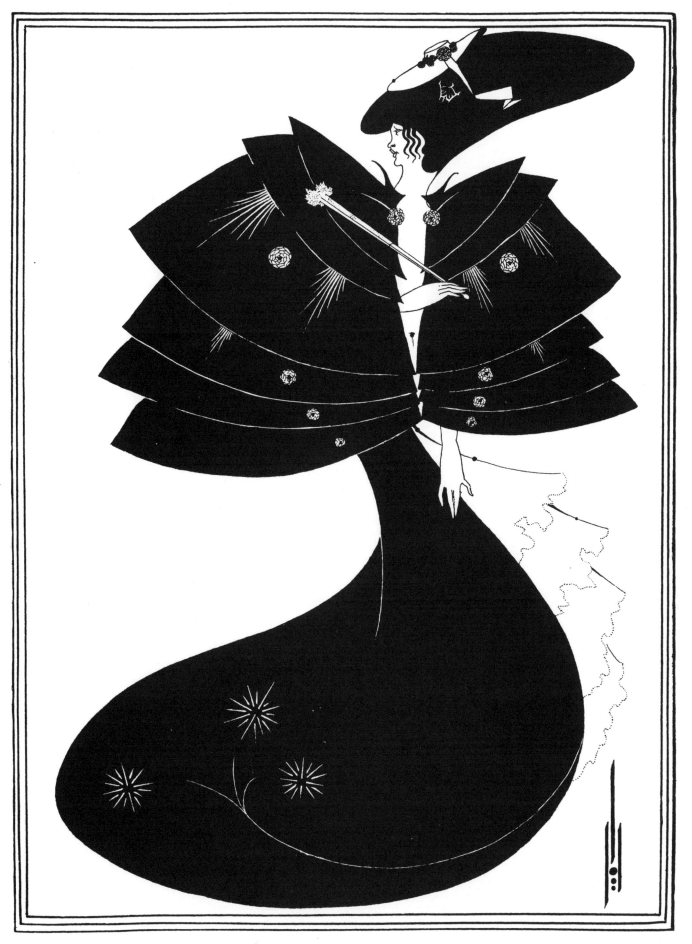

PLATE 19

The Eyes of Herod

In contrast to *The Black Cape* (pl. 19), this is completely in the spirit of Wilde's text, although it too contains much that is factually incomprehensible, in particular the absence of Herod's body. It is perhaps too lavishly furnished with the properties of Art Nouveau, in particular the peacock and peacock's feathers and the over-elaborate candelabrum.

Drawing for an illustration in *Salome*
1894
Pen and ink, 8¾ × 6⅞"
Fogg Art Museum, Harvard University,
Cambridge, Mass. Grenville L. Winthrop Bequest

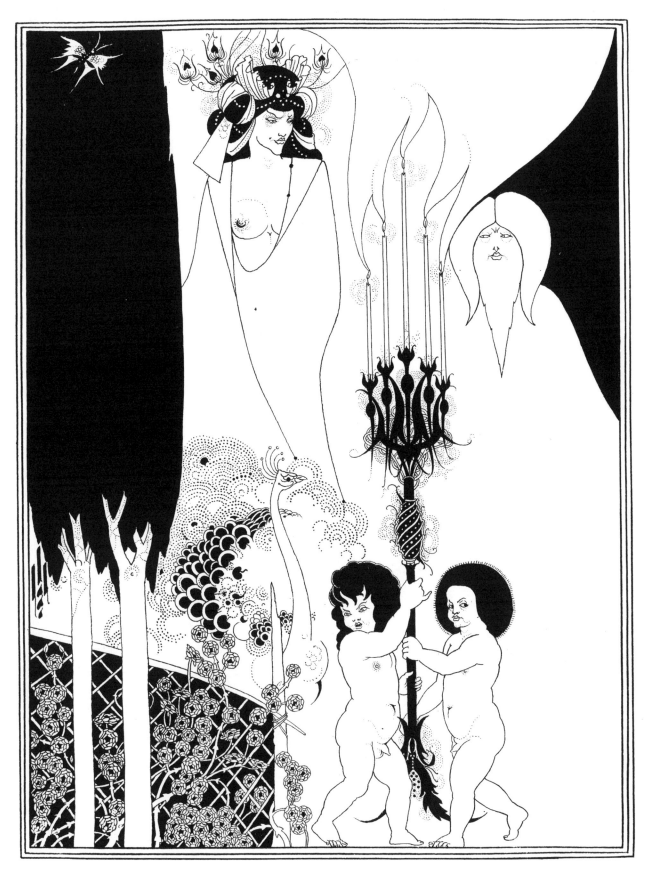

PLATE 20

The Toilet of Salome
(second version)

By the time the second version of this subject was
done, Beardsley had grown tired of the archaic
clothes of the other *Salome* drawings, which gave
them a touch of Pre-Raphaelite artificiality.
Salome is in an almost contemporary costume and
an Ascot hat. This has allowed him greater free-
dom; in fact, it is one of the most astonishing of all
Beardsley's designs. Salome has no arms, and it is
impossible to say how her dress is constructed,
but we accept it owing to the marvelous sweeping
movement. On the other hand, the dressing table
is drawn most carefully and represents the revolu-
tion in furniture design that had been initiated by
Whistler a few years earlier and carried out by E.
W. Godwin. Perhaps the emptiness of the room
also shows the influence of Whistler. While omit-
ting so many details, Beardsley has put in the
names of Salome's books. They are, of course, his
own favorites: *The Golden Ass* of Apuleius, *Manon
Lescaut,* the Marquis de Sade, *Fêtes Galantes,* and
Zola's *Nana.*

Drawing for an illustration in *Salome*
1894
Pen and ink, $8^{13}/_{16} \times 6^{5}/_{16}''$
British Museum, London

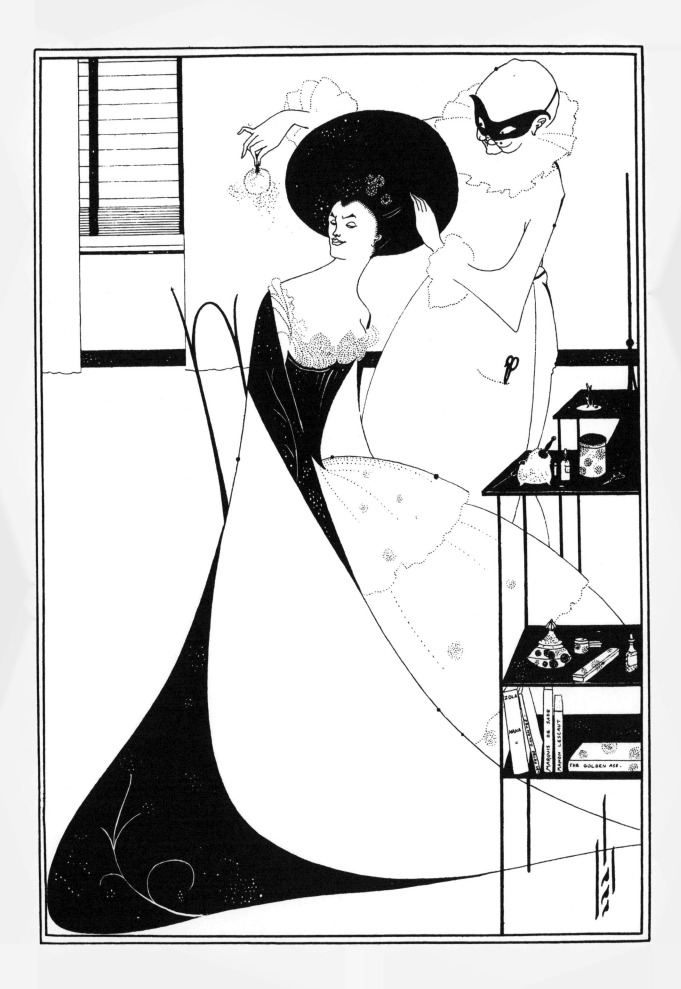

The Dancer's Reward

One does not expect to find oneself describing Beardsley's work as "grandiose," but the word comes unbidden to one's mind before this splendid drawing. The long fall of Salome's cloak, the loops of her scarf, her hand grasping a lock of St. John's hair, and the horrified expression with which she regards his head are the material of tragedy. It is one of his works which justifies the words of Oscar Wilde, that there were "great possibilities always in the cavern of his soul."

Drawing for an illustration in *Salome*
1894
Pen and ink, 8¾ × 6¼"

Fogg Art Museum, Harvard University,
Cambridge, Mass. Grenville L. Winthrop Bequest

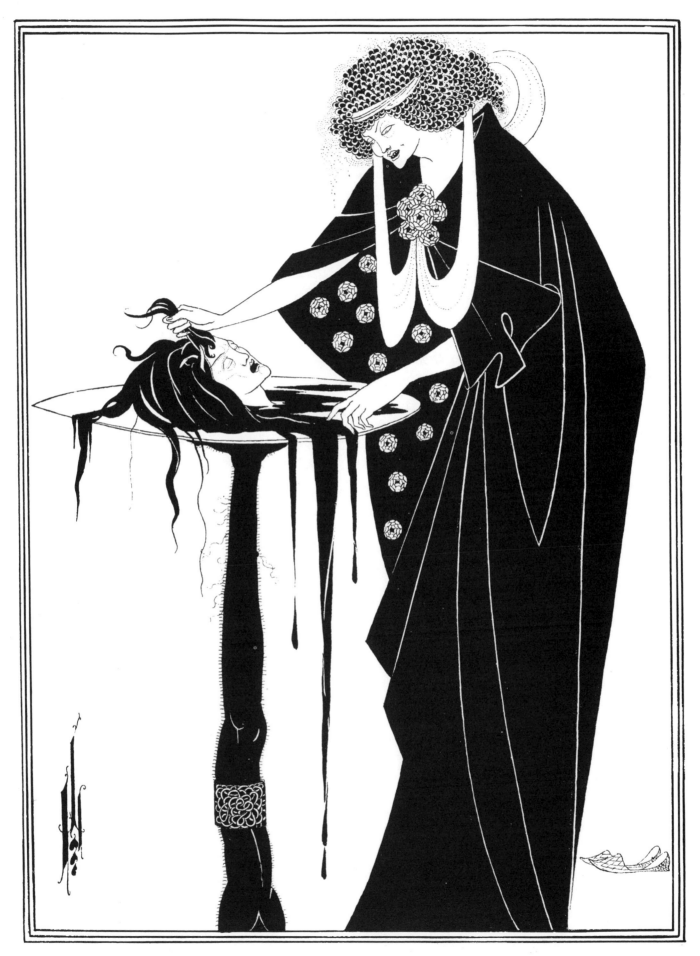

PLATE 22

Enter Herodias

The most evil of all Beardsley's drawings. The goblin is at his most horrific; the epicene figure on the right, whose private parts were covered with a fig leaf when the *Salome* drawings were first published, is a revolting auxiliary of vice. Herodias herself is superbly wicked. This effect is achieved by very simple means—the mane of black hair, the impossible breasts, and the black sash beneath them. These are pictorial devices, related to the black base of the stage before which stand the horrible candles. The showman on the right is usually said to represent Oscar Wilde, but I have never seen any evidence that this was Beardsley's intention, or that Wilde recognized the resemblance. We return to Herodias's face. It is impassive, confident that vice will win the day.

Drawing for an illustration in *Salome*
1894
Pen and ink, 7 × 5^1/$_{16}$"
Princeton University Library, Princeton, New Jersey

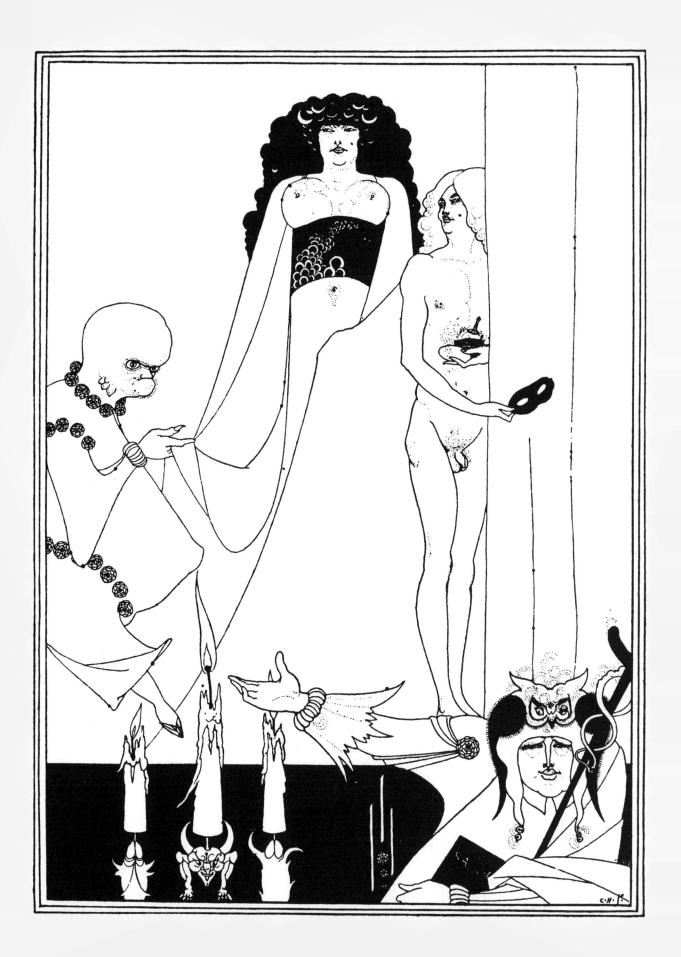

Chopin Ballade III

This used to be considered Beardsley's most "important" drawing; it is certainly his most conventional. Not only does it lack his diablerie, but the shapes are uninteresting and the prancing horse is an academic formula. But it has an element of poetry, especially when associated with Chopin's ballade, and even a small selection of Beardsley's work would have been incomplete without it.

1894
Indian ink, and ink and watercolor washes
10⅛ × 9½″
Collection Colonel Mahlon C. Sands, England

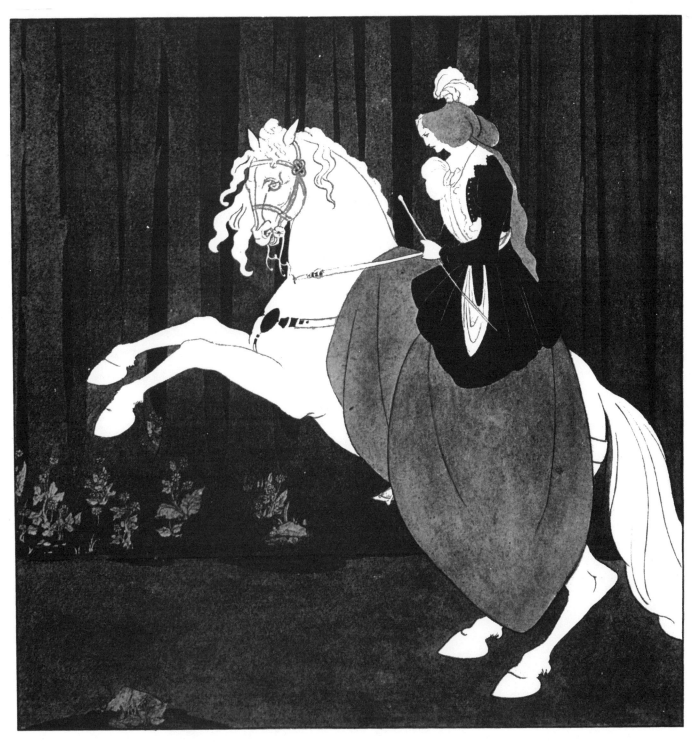

PLATE 24

La Dame aux Camélias

This drawing was first published in the journal *St. Paul's* with the title *A Girl at Her Toilet,* and there is no reason to believe that Beardsley had in mind the heroine of Dumas's play. For some unknown reason Beardsley added watercolor washes of a pinkish-purple, which has made the drawing less effective. When originally published it was one of the most popular of all his drawings, but it is far from being the most interesting.

Drawing for an illustration in *The Yellow Book,*
VOLUME III
October 1894
Indian ink and watercolor, 11 × 7⅛″
Tate Gallery, London

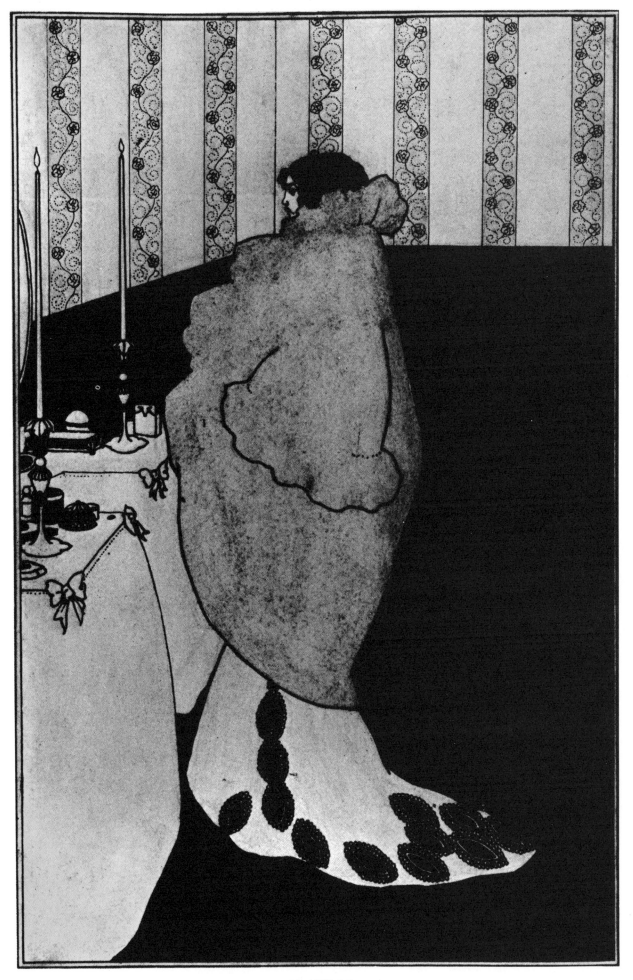

PLATE 25

The Fat Woman

This is one of Beardsley's most masterly drawings. The bulk of the bodice, the black gloves and their relation to the bottle remind one of the first "abstract" painters of about 1910. It was said to represent Mrs. Whistler, and for this reason Lane refused to reproduce it in *The Yellow Book*. Beardsley wrote to him: "Yes, my dear Lane, I shall most assuredly commit suicide if the *Fat Woman* does not appear in No. 1 of *The Yellow Book*. . . . I shall hold demonstrations in Trafalgar Square."

He gave the drawing, with an inscription on the back, to Sir William Rothenstein. Rothenstein returned it to him, asking him to destroy it, which may be taken as evidence that it *did* represent Mrs. Whistler, as otherwise there is nothing objectionable about it. Compared to Herodias, the face is almost amiable.

Drawing for an illustration in *To-Day*
May 1894
Indian ink and wash, 7 × 6⅜"
Tate Gallery, London

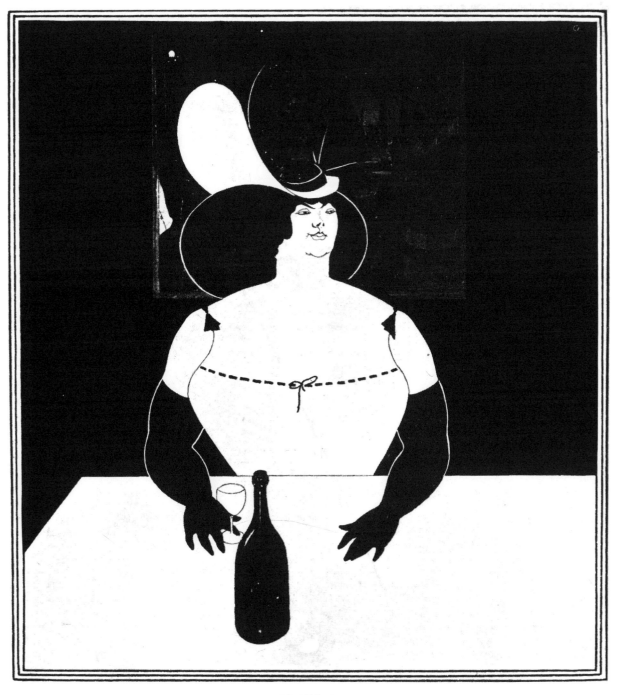

PLATE 26

Rejane (Portrait of Madame Réjane)

Madame Réjane appeared in London in *Madame Sans-Gêne* in 1894, and Beardsley met her then; but he had certainly seen her before in Paris. He developed the most fervent admiration for her and depicted her in a number of media, including a beautiful red chalk drawing which seems to have been done from the life, and a pen-and-ink sketch which is also a life study of a kind almost unique in Beardsley's mature work, probably done when she was in London. A beautiful outline drawing in *The Yellow Book* is in his more abstract style. The Metropolitan drawing is the finest of these tributes and is indeed one of the most exquisite of Beardsley's works. It shows how little, after all, his work was dependent on diabolism. Accents are often omitted in French capital letters, and the inscription REJANE is no doubt intentional.

c. 1894
Indian ink and wash, 13¼ × 8¾"
Metropolitan Museum of Art, New York

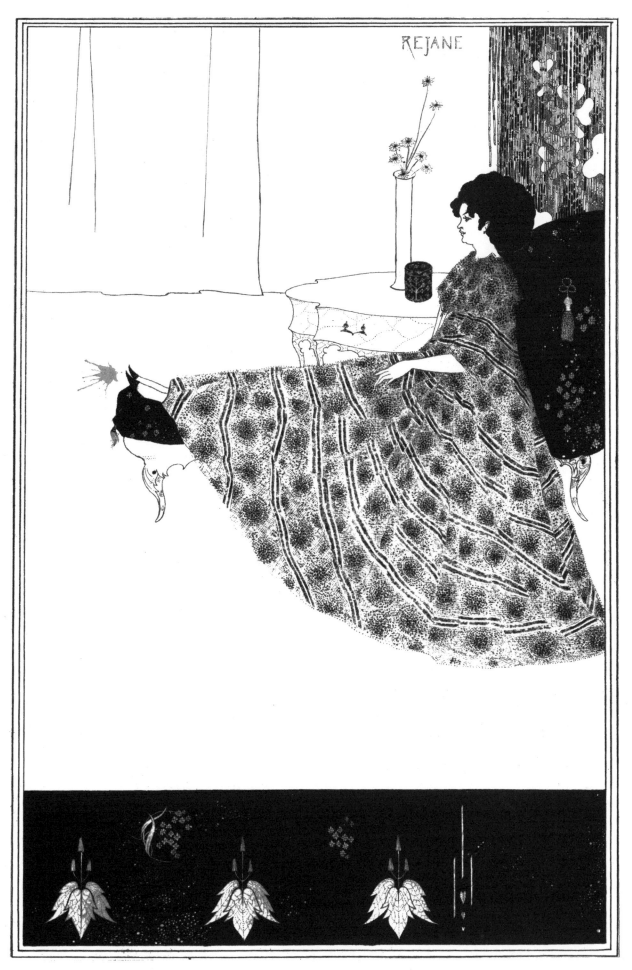

REJANE

PLATE 27

Invitation Card to the Opening of the Prince's Ladies Golf Club at Mitcham, Surrey, on July 16, 1894

Beardsley was prepared to carry out hack work of all kinds. It was a relaxation from the strain placed on his imagination by *Salome.* But how he came to do an invitation to the opening of a golf club remains a mystery. He took the opportunity of making the ladies' dresses as unsuitable as possible: they are in fact one of his most splendid travesties of contemporary costume. The ladies must have been indignant; nor can they have looked with much patience at the pierrot caddy. But Beardsley lived in his own world, and if normal people or institutions chose to employ him, they had to put up with what they got.

Pen and ink, 9 × 5½"

Collection Mrs. R. Hippisley-Coxe, England

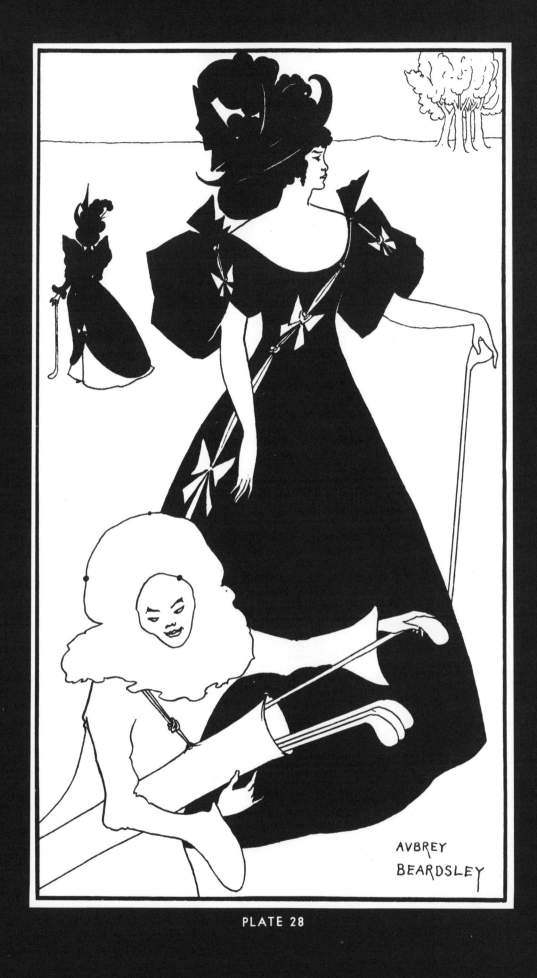

PLATE 28

Caricature of Whistler

This example of Beardsley's naughtiness (for he owed Whistler an immense debt) was unknown until it was published in 1923. But Beardsley had already caricatured his master on the title page of a book called *The Dancing Faun,* in which Whistler's famous white lock is transformed into a horn. As mentioned in the introduction, Whistler spoke movingly of Beardsley's genius. The head is rendered with great skill, and the way it is placed at the very top of the design, leaving the bottom of the page blank, is typical of Beardsley's freedom from the usual conventions of composition. The butterfly signature has been partially erased.

In spite of his genius as an artist, those who knew Whistler in the 1890s have told me that he had become very tiresome.

c. 1893–94
Pen and ink, $8^{1}/_{16} \times 4^{7}/_{16}''$
National Gallery of Art, Washington, D.C. Rosenwald Collection

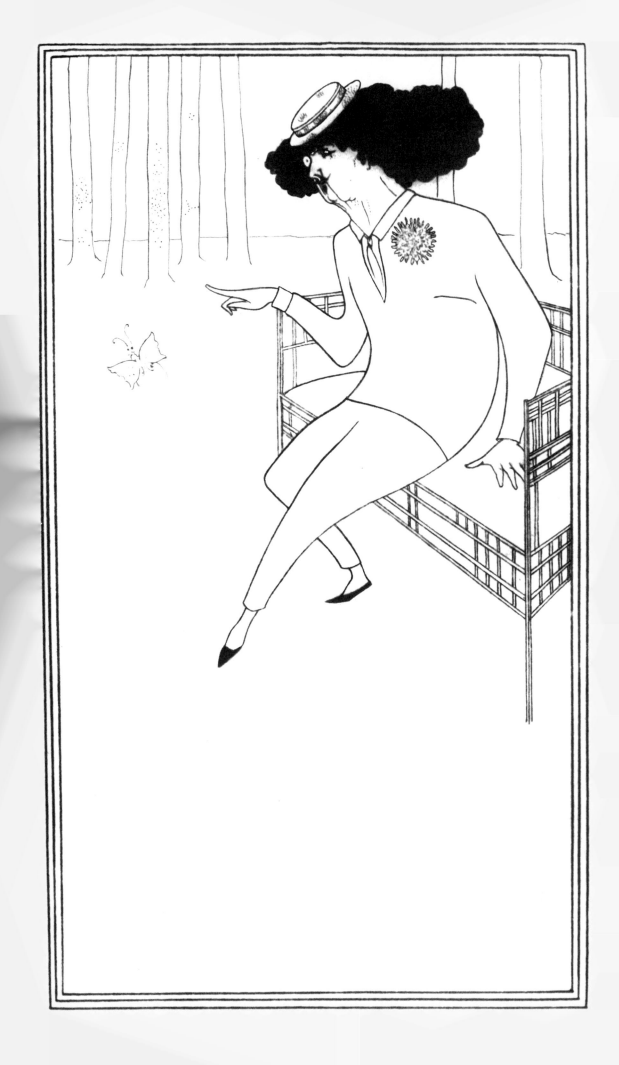

Design for the front cover of the prospectus of *The Yellow Book*, VOLUME I

The Yellow Book was conceived by John Lane as an avant-garde periodical. It was bound in hardboards with a yellow cover on which was printed the list of contents. In the first four numbers the covers, back and front, were designed by Beardsley, who was art editor. It contained many of his finest drawings and (since he could not find work of other artists that pleased him) a few in which he adopted other styles, including pastel. They were attributed to fictitious artists, and Beardsley was delighted when a reviewer advised him "to study and profit by the sound and scholarly manner of which Mr. Philip Broughton furnished another example in his familiar manner." The drawing in question, a profile of Mantegna, is obviously by Beardsley.

The prospectus is exceptional in his work in that his absolute black and white has been used to create an effect of light. The pierrot bookseller is said to be a portrait of Lane's partner, Elkin Mathews, who viewed *The Yellow Book* with apprehension and clearly disapproved of the lady's desire to buy it.

April 1894
Pen and ink, 9½ × 6⅛"
Victoria and Albert Museum, London

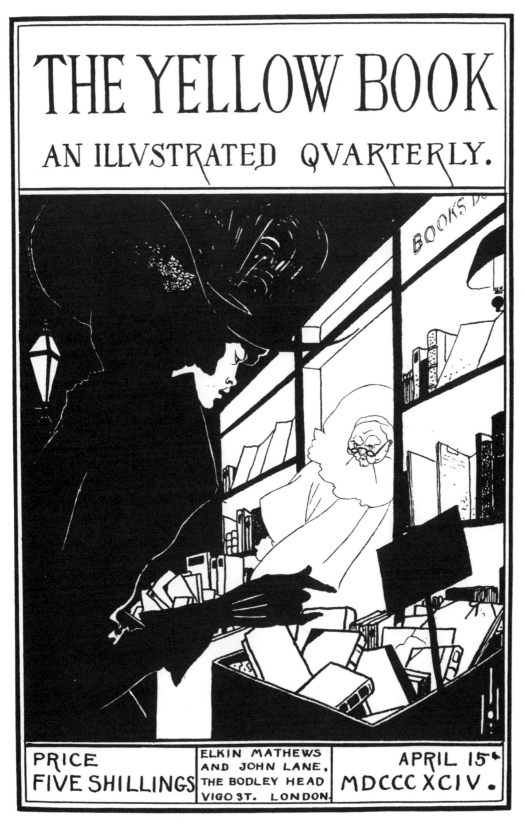

PLATE 30

L'Education Sentimentale

This is the archetypal Beardsley drawing. Its theme is corruption. The revolting old party is adding to the corruption, already manifest, of the young woman, who receives her advice with complacent foreknowledge. Technically it is one of his most perfect drawings. The simple outline of the old woman is marvelously revealing; the balance of black and white extends to the old lady's shoe. For some inscrutable reason Beardsley destroyed this work, or rather cut out the old woman and colored her (see pl. 32).

Illustration in *The Yellow Book,* VOLUME I
April 1894
Reproduced from the half-tone plate, now cut up

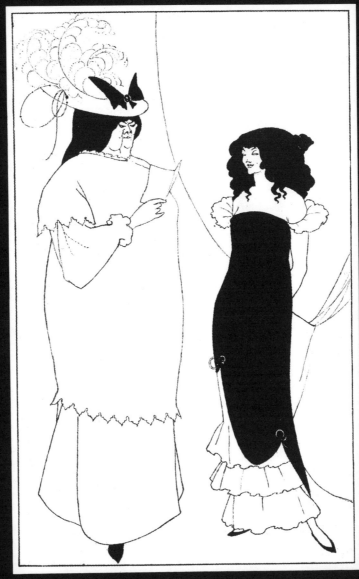

PLATE 31

Mrs. Marsuple, from L'Education Sentimentale

As stated in the remarks to plate 31, no one knows why Beardsley chose to cut up one of his finest drawings. The young lady is lost, and the older one, the original Mrs. Marsuple, was colored with pink and green watercolor and given a dark skirt. Beardsley usually knew what he was doing, but in this case I think he made a mistake.

1894

Pen, ink, and watercolor, 10¾ × 3½″

Fogg Art Museum, Harvard University,
Cambridge, Mass. Grenville L. Winthrop Bequest

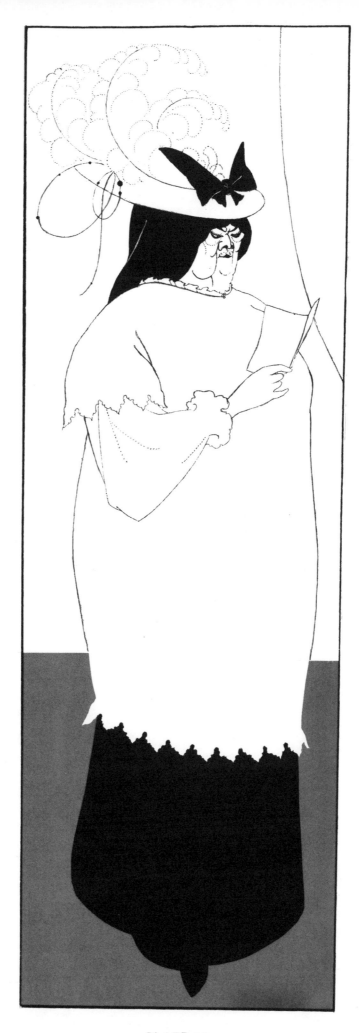

PLATE 32

A Night Piece

Bored by praise for the precision of his line (see pl. 34), Beardsley enjoyed doing a drawing with no lines at all except those scratched by a knife on a black surface. Perhaps he was influenced by Whistler's *Nocturne,* which had been ridiculed by Ruskin in 1877. His friend Burne-Jones had said at the famous trial for libel against Ruskin that Whistler's *Battersea Bridge* "was only one of the thousand failures to paint night." As so often, there was an element of perversity in Beardsley's drawing, not only in the darkness, but in placing the figure so far to one side. But it is a charming work without any hint of wickedness.

Drawing for an illustration in *The Yellow Book,*
VOLUME I
April 1894
Ink and wash, 12⅝ × 6⅛"
Fitzwilliam Museum, Cambridge, England

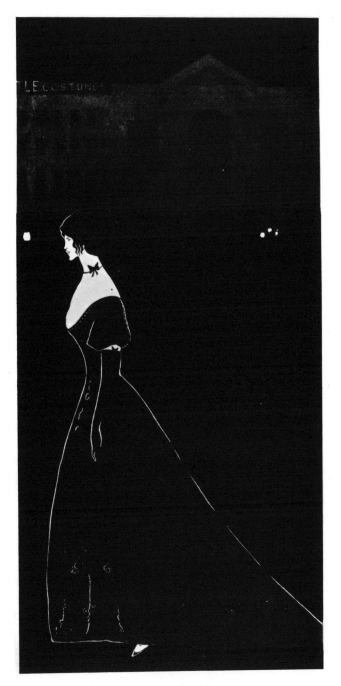

PLATE 33

Mrs. Patrick Campbell

Through the intervention of Oscar Wilde, Beardsley secured an interview with Mrs. Patrick Campbell, who was then enjoying a triumphant success in Sir Arthur Pinero's play *The Second Mrs. Tanqueray.* In a letter of February, 1894, he thanked her for a sitting. But he made no attempt to profit by this opportunity, and his drawing can never have had the slightest resemblance to its sitter. For this reason it was greeted with indignation when it appeared and referred to as a caricature. It is, however, an enchanting piece of work and shows more than almost anything else the purity of line to which his admirers often referred. I have suggested in the text that it is an idealized portrait of his mother, Miss Pitt, known from her excessive slenderness as "the bottomless Pitt."

The drawing became the property of Oscar Wilde.

Drawing for an illustration in *The Yellow Book,*
VOLUME I
April 1894
Pen and ink, $13^1/_{13} \times 8^3/_8''$
National Gallery, Berlin

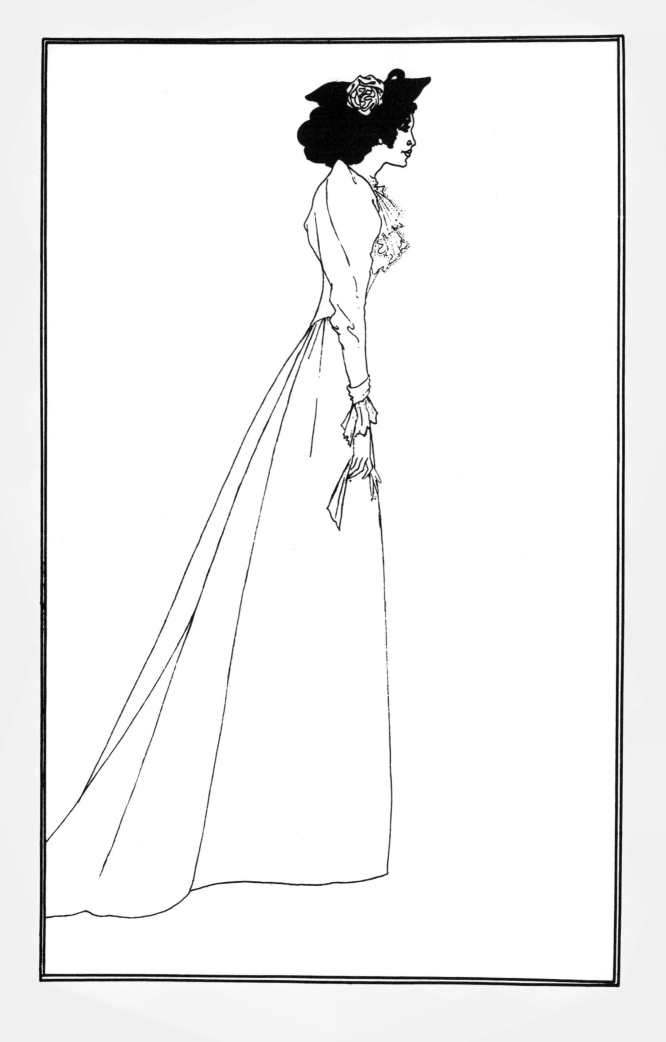

Design for the title page of
The Yellow Book, VOLUME II

The use of black and white areas, presumably intended to represent grass, is an inconspicuous example of the hard-edge abstraction that so often dominates Beardsley's work. The lady is a characteristic and engaging representation of his ideal of feminine charm. Although conceived over eighty years ago, she is still in the contemporary mode. I cannot imagine myself picking up a Rossetti "stunner," or making advances to a Burne-Jones; but this Beardsley girl, with her slightly tip-tilted nose and very short upper lip, would make me turn my head. She is, however, an unusually amiable example of the Beardsley woman; more often she looks much more dangerous, as in *The Yellow Book* prospectus (pl. 30), or positively vicious.

July 1894
Pen and ink, $3^{11}/_{16} \times 3\frac{5}{8}''$
Princeton University Library, Princeton, New Jersey

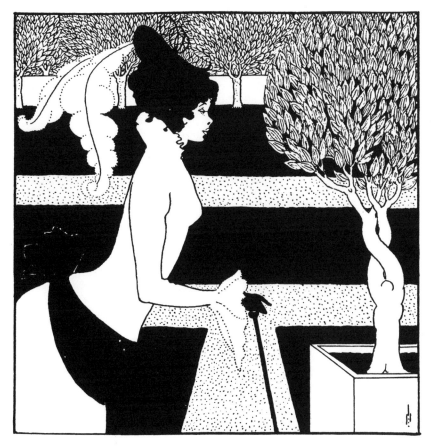

PLATE 35

Garçons du Café

Beardsley originally called it *Les Garçons du Café Royale,* so it is unique in Beardsley's work as it goes back to an actual experience and not to an idea. It shows, as do some of the illustrations to *Bons-Mots,* that Beardsley could observe real human beings if he chose to do so. The contrasted types of the waiters is convincing. The movement of the black areas, interrupted by plate and napkins, is a remarkable piece of design and gains something from the less-formalized shapes of the waiters' coats. Could Beardsley have gone farther in this direction? There are certain indications in the later drawings that he could.

Illustration in *The Yellow Book,* VOLUME II
July 1894
Reproduced from the line block

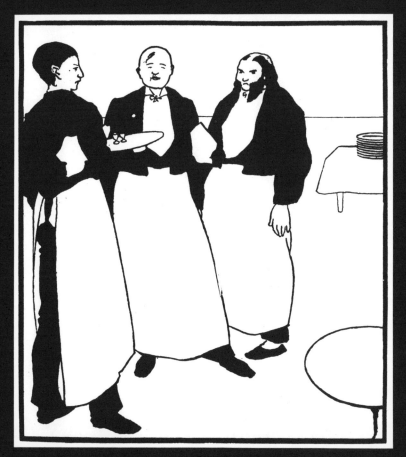

PLATE 36

Portrait of Himself

The drawing is inscribed with the words: PAR LES
DIEUX JUMEAUX TOUS LES MONSTRES NE SONT
PAS EN AFRIQUE. The little figure with the mob
cap, peering out of the sheets of the enormous
bed, bears no resemblance to Beardsley and is
simply one of his ideal heads, male or female. But
it is his young self because he is lonely, only just
daring to emerge from the protection of the
enormous bed curtains that hang majestically
from an inexplicable tester. We feel that at any
moment he may withdraw from the real world and
indulge in the kind of soliloquy which I have
quoted in the introduction (p. 41).

Illustration in *The Yellow Book,* VOLUME III
October 1894
Reproduced from the line block

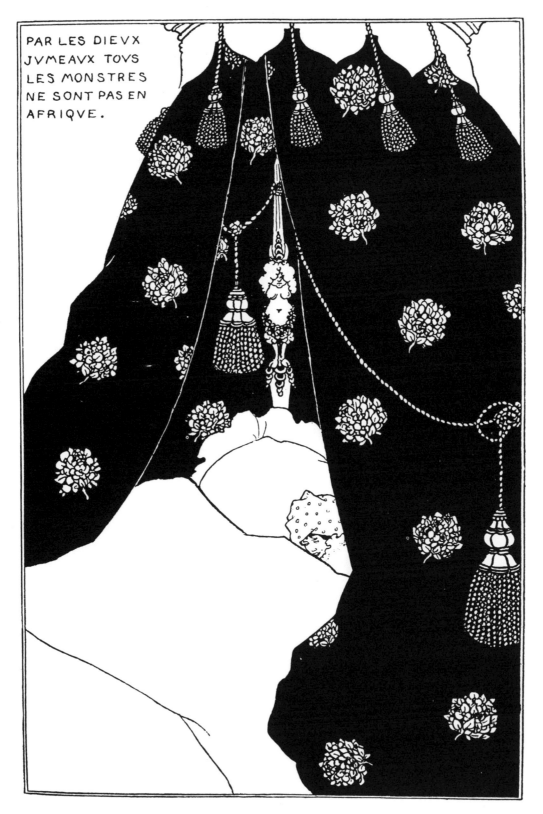

PLATE 37

Lady Gold's Escort

Beardsley's contemporaries often referred to his work as satire. Insofar as the satirist pretends to expose vice in order that it may be diminished, the word cannot be applied to Beardsley, as corruption amused him and he did not wish to reform anyone. But two of the drawings in Volume III of *The Yellow Book* can be called satire in so far as they brilliantly depict a corrupt society. *Lady Gold's Escort* is a commonplace theme, but the men who surround her, with their huge white shirts, top hats, and baggy trousers, brilliantly portray various types of depravity, from the prosperous to the near-suicidal. The youth with a white muff, who follows her, brilliantly anticipates the Russian ballet.

Illustration in *The Yellow Book,* VOLUME III
October 1894
Reproduced from the line block

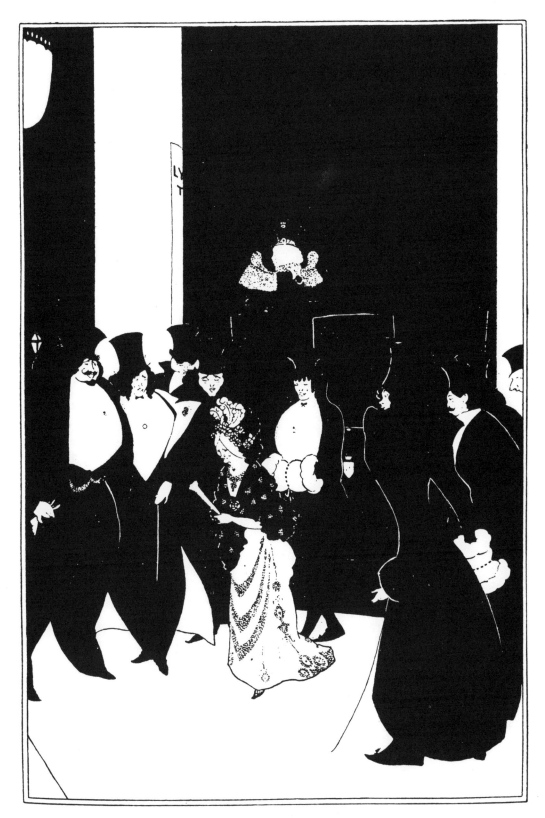

PLATE 38

The Wagnerites

The next plate in *The Yellow Book, The Wagnerites,* is Beardsley's most famous satiric drawing, and here, perhaps, he did feel some indignation at the sight of these corrupt women witnessing the great poem of ideal love, which moved him more than any other work of his time, *Tristan and Isolde.* He has excelled himself in depicting evil. The face of the woman on the extreme right is a new invention. The only man depicted is milder than the women, but not in other respects their superior.

This drawing continues the black style that appeared first in *A Night Piece* (pl. 33). It is said that this interest in darkness was the result of Whistler's *Nocturnes,* but I rather doubt this. One cannot imagine anything less Whistlerian than *The Wagnerites.* This technique was difficult to reproduce. In *The Yellow Book* reproductions the quantity and quality of the scratched lines vary considerably from the original.

Drawing for an illustration in *The Yellow Book,*
VOLUME III
October 1894
Pen and ink, touched with white, 8⅛ × 7″
Victoria and Albert Museum, London

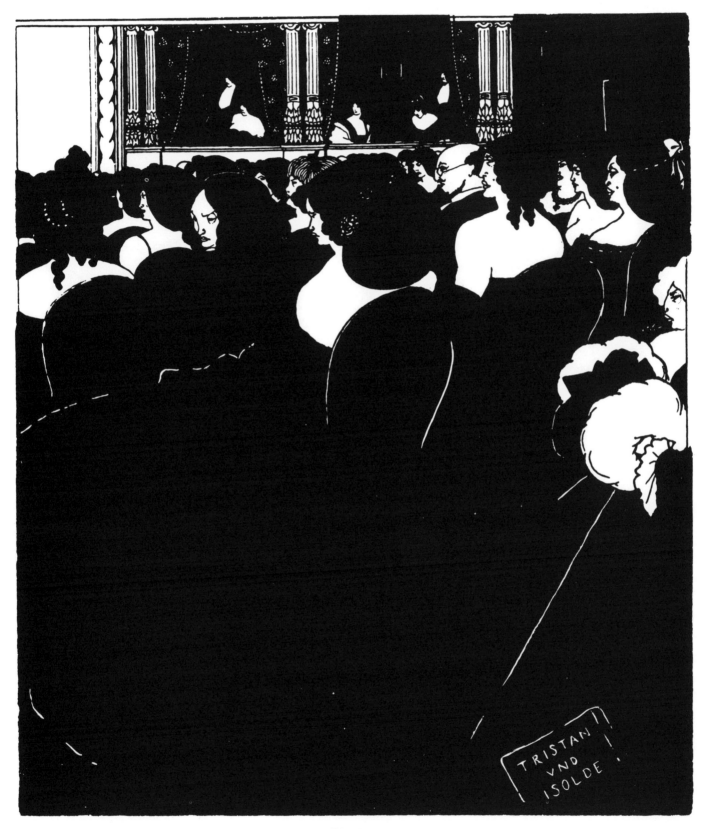

PLATE 39

The Mysterious Rose Garden

I have written about this drawing at some length in the text, following Beardsley's statement that it represented the Annunciation and that he had intended it to be the first of a series of Biblical illustrations. Mr. Brian Reade believes that Beardsley abandoned this idea, and that the girl is intended to be pregnant. The mysterious mercurial figure with long hair, a woman's dress, and a moustache is telling her of the miseries that will attend an unmarried mother. I can see no indication that the girl is pregnant. Mr. Reade says that she probably represents Aubrey's sister Mabel, which may be true, but if so Mabel could also be the flagellant in plate 43.

Whatever its meaning, this is one of Beardsley's most moving drawings. Once more he has been inspired by the corruption of innocence, but the naked girl is more disarmingly innocent and the corruption more exquisitely persuasive.

Drawing for an illustration in *The Yellow Book,*
Volume IV
January 1895
Indian ink (with original pencil still visible)
8¾ × 4¾"

Fogg Art Museum, Harvard University,
Cambridge, Mass. Grenville L. Winthrop Bequest

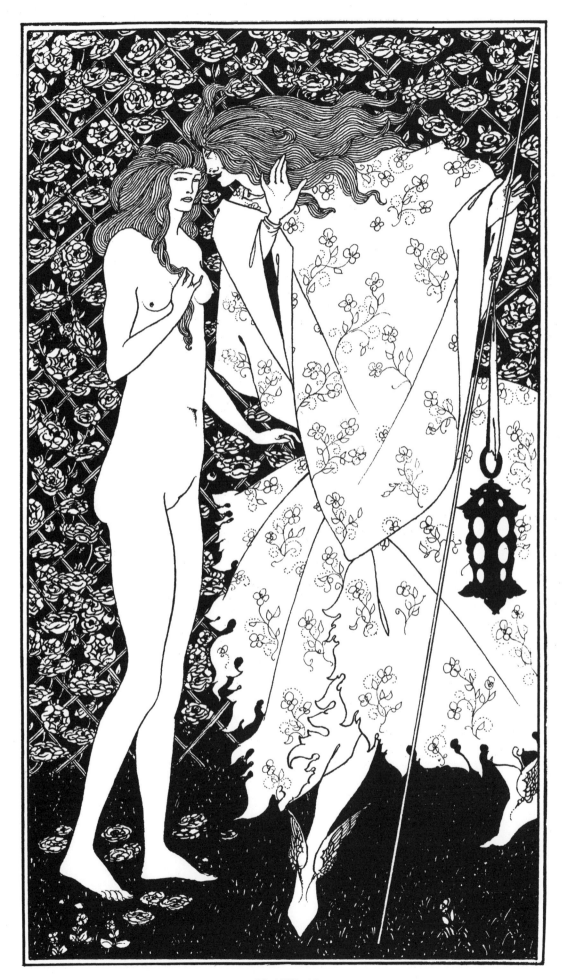

PLATE 40

Frontispiece to Juvenal

This is the last drawing to be published by Beardsley in *The Yellow Book*. The others, which had been prepared before Lane dismissed him, were withdrawn. A year later Beardsley did three more drawings for Juvenal's *Sixth Satire,* which were published by Smithers in 1906. They are among his most revolting works. The wicked old party whose profile is just visible in the palanquin could have been one of the Wagnerites. The point of the drawing is the extreme impassivity of the monkey footmen. The background makes no attempt to look like Rome, but is a mixture of London and Brighton and is a reminder that Beardsley spent several months in an architect's office in London.

Illustration in *The Yellow Book,* VOLUME IV
January 1895
Reproduced from the line block

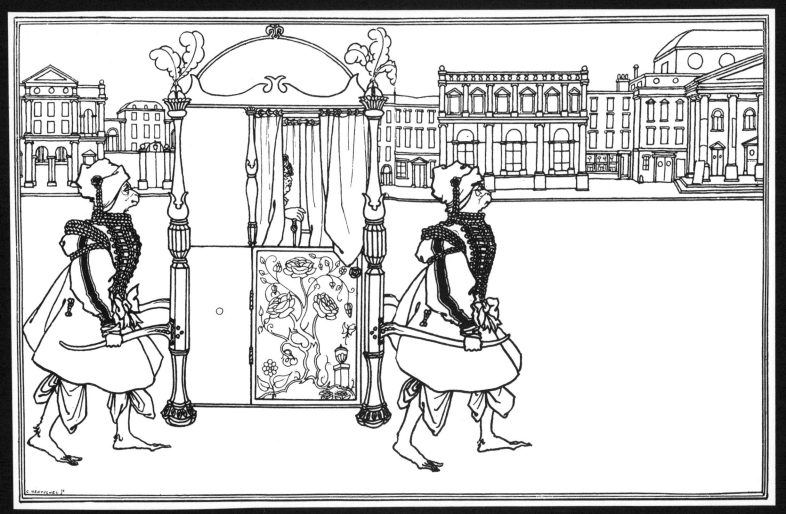

PLATE 41

The Spinster's Scrip

Comparable to the *Prince's Ladies Golf Club* (pl. 28), this drawing shows an even more drastic stylization of contemporary costume. I have suggested in the text that the sleeves were influenced by the great French poster designer Chéret, but Chéret never arrived at the sharp angles that make the spinster with the dog's lead such a formidable character. In some reproductions a dog is shown, but it does not appear in the original drawing.

This must be one of the last of Beardsley's commercial jobs and is one of the most powerful.

Design for a poster advertising a book published by
William Heinemann
1895
Pen and ink, 14¼ × 9⁵/₁₆″
Princeton University Library, Princeton, New Jersey

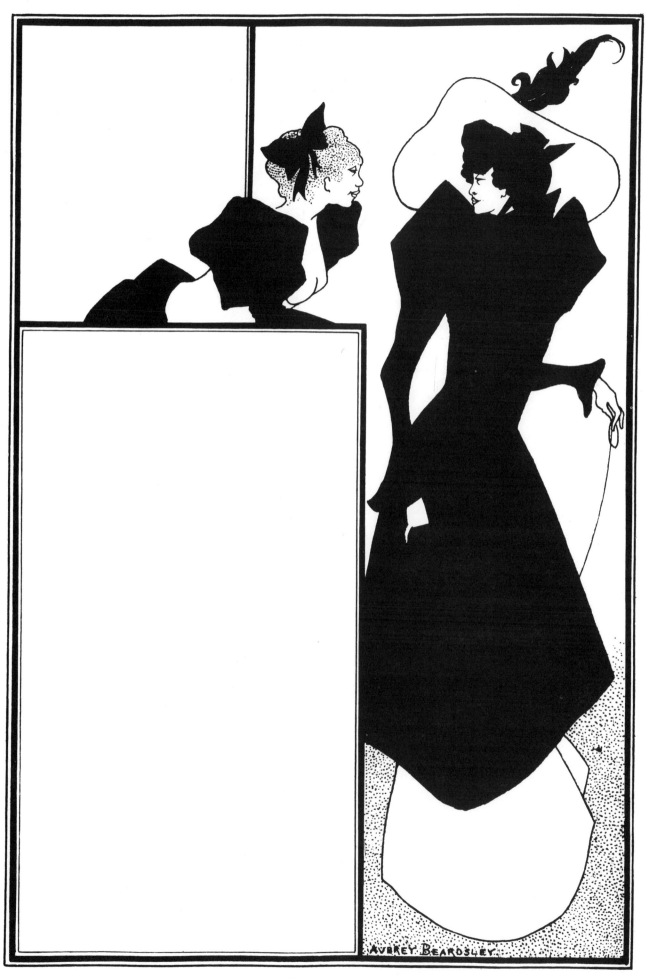

PLATE 42

Drawing for the frontispiece of John Davidson's *A Full and True Account of the Wonderful Mission of Earl Lavender*

Although a volume of the Marquis de Sade is one of the books that Beardsley put on Salome's dressing table, he himself does not seem to have been a devotee of flagellation, but it was practiced enthusiastically in the post-Swinburnian era, and Beardsley's beautiful drawing of the exercise was probably intended to tease those of his friends who treated it seriously. It has absolutely no resemblance to the relevant passage in John Davidson's *Earl Lavender,* which describes the flagellation as taking place in "a large room hung with tapestry and furnished with rugs, cushions and couches." Beardsley's scene is set in his usual small, middle-class room with Victorian furnishing made, by his economical skill, to look classically beautiful. The room in *Earl Lavender* is full of eager flagellants waiting their turn. Beardsley shows only part of one kneeling figure and a prim young lady, who discharges her duty with amused *hauteur.*

1895
Pen and ink, 10⅛ × 6³/₁₆"
Fogg Art Museum, Harvard University,
Cambridge, Mass. Grenville L. Winthrop Bequest

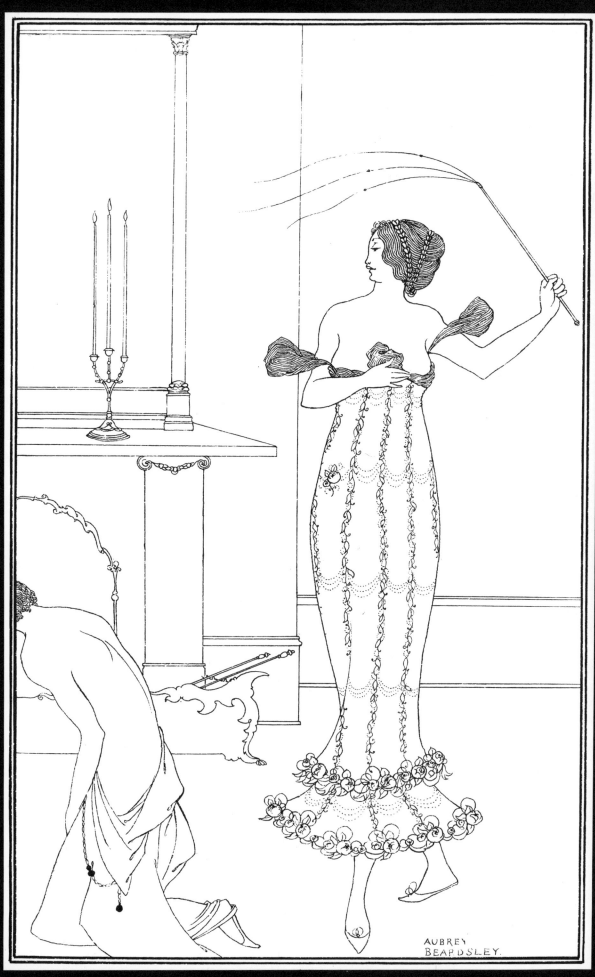

AUBREY
BEARDSLEY.

PLATE 43

The Return of Tannhäuser to the Venusberg

Inscribed on the back "To J.M. Dent my kind friend, and first publisher: from Aubrey Beardsley. Sept. 1896." This was to be one of twenty-four illustrations of Beardsley's romantic novel, *The Story of Venus and Tannhäuser,* which was announced by John Lane in 1894 but never printed by him, presumably because Beardsley's text is so indecent. The complete text was printed privately in 1907.

The image of Tannhäuser returning to the Venusberg in pilgrim's clothes is the subject of one of the first drawings he did with feeling (pl. 1), and there is no doubt that the idea of renunciation and return lay at the center of his spirit. Both drawings follow the same basic design, but a comparison between them shows how enormously Beardsley's powers as an artist had developed in five years. The combination of deep feeling and elaborate technical skill—for example the brambles are tinted with a wash—makes this one of Beardsley's greatest drawings.

1896
Pen, ink, and wash, 5¼ × 5³/₁₆"
Collection F. J. Martin Dent, London

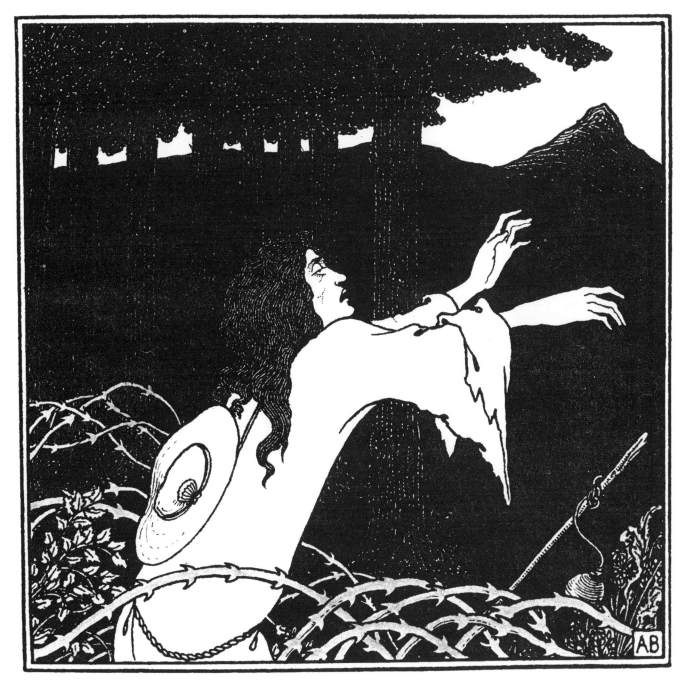

PLATE 44

Messalina Returning Home

An illustration to the *Sixth Satire* of Juvenal, this is one of Beardsley's most explicit studies of evil, which is conveyed not only in Messalina's head but in all her accounterments, her shoe and the twisted corner of her cloak. The line of her frills is quite abstract; in fact, line in this drawing hardly counts. Everything is achieved by the areas of black and white, including the brutal lurch forward of Messalina's body. Horrible as this is, Beardsley achieved, two years later, an even more repulsive image of Messalina (see pl. 58).

Drawing for an illustration of the
Sixth Satire of Juvenal
1895
Pencil, ink, and watercolor, 11 × 7"
Tate Gallery, London

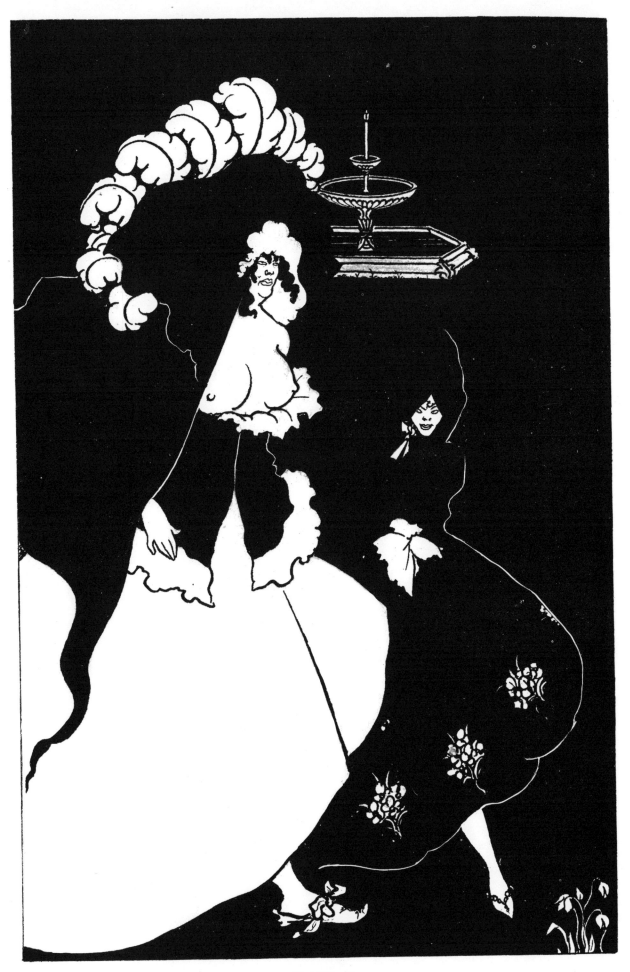

PLATE 45

Black Coffee

The last drawing in *The Yellow Book* style, *Black Coffee* was intended for Volume V of this periodical, but was withdrawn in April, 1895, when Beardsley was dismissed. He then suggested to Elkin Mathews that it could be used as the frontispiece of a novel by Walter Ruding called *An Evil Motherhood,* but it had no connection with the book and appears in only six copies. Beardsley then did an alternative frontispiece, which perfectly illustrates the book's theme.

Black Coffee shows his love of contrasting very plain areas (a tabletop and menu) with very elaborate ones (the ladies' hats). Personally I find that the artificial eyebrows of the lady on the left (or are they part of her *chevelure?*) distract from what would otherwise be a fine drawing. The relationship between the two ladies is worthy of Toulouse-Lautrec, whose work Beardsley probably saw in Paris.

Drawing for the frontispiece of Walter Ruding's
An Evil Motherhood
1896
Pen, ink, and wash, 6⅛ × 6¼"
Fogg Art Museum, Harvard University,
Cambridge, Mass. Scofield Thayer Collection

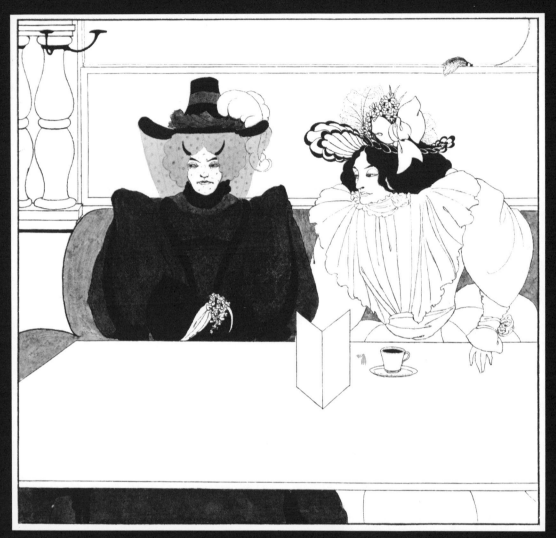

PLATE 46

A Suggested Reform in Ballet Costume

This pretty but relatively unimportant drawing is interesting because of the title given to it by Beardsley. I mention in the essay Diaghilev's profound admiration for him. He published an article on Beardsley in the periodical he edited, *Mir Iskusstva,* and is said to have met him in Dieppe. No doubt if Beardsley had lived he would have become a linchpin of Diaghilev's Russian ballet. As it is, this drawing, with its half-serious title, anticipates the great revolution of *Aurora's Wedding.*

Drawing for an illustration to Justin McCarthy's poem "At a Distance," published in an anthology in
1895
Pen and ink
Collection W. G. Good, England

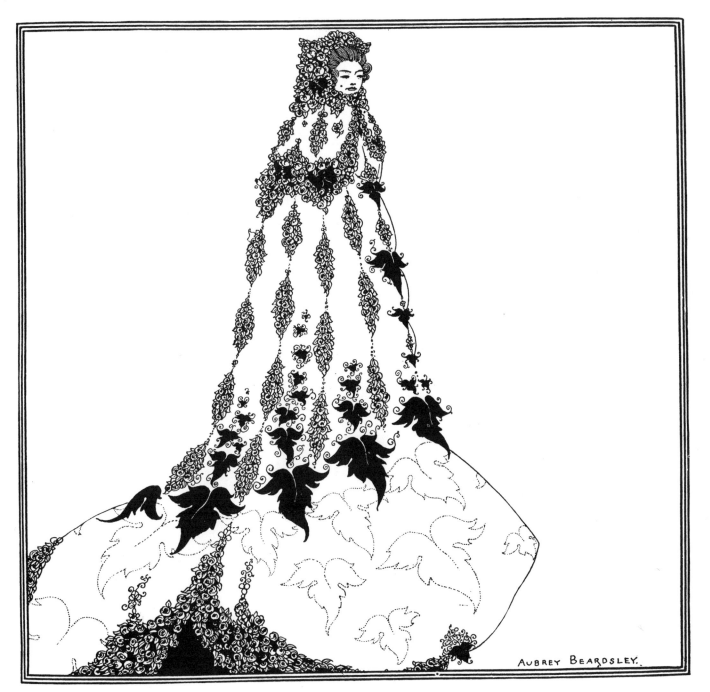

PLATE 47

The Toilet

Smithers published an edition of Pope's *Rape of the Lock* "embroidered with nine drawings by Aubrey Beardsley." The word "embroidered" was evidently meant to forestall complaints that Beardsley had not illustrated this famous work with sufficient accuracy. But as a matter of fact his drawings are far closer to the text than are those for *Le Morte Darthur* and *Salome*. The drawings are in a traditional style derived from the work of French eighteenth-century engravers such as that of Nicolas Cochin *père*. They were, in Beardsley's lifetime, the most admired of his works, but they lack the originality and terrible impact of the *Salome* drawings or *The Wagnerites*. The transposition of an engraving into pen and ink was fundamentally a mistake. Nevertheless, they remain admirable. Hidden under their elaborate surfaces is Beardsley's unique sense of area conveyed by contrasting textures, and as illustration *The Toilet* realizes to perfection Pope's long description which is one of the most enchanting passages in the poem. How Beardsley must have loved it!

Drawing for an illustration in Pope's
The Rape of the Lock
1896
Pen and ink, 10 × 6¾"
Cleveland Museum of Art

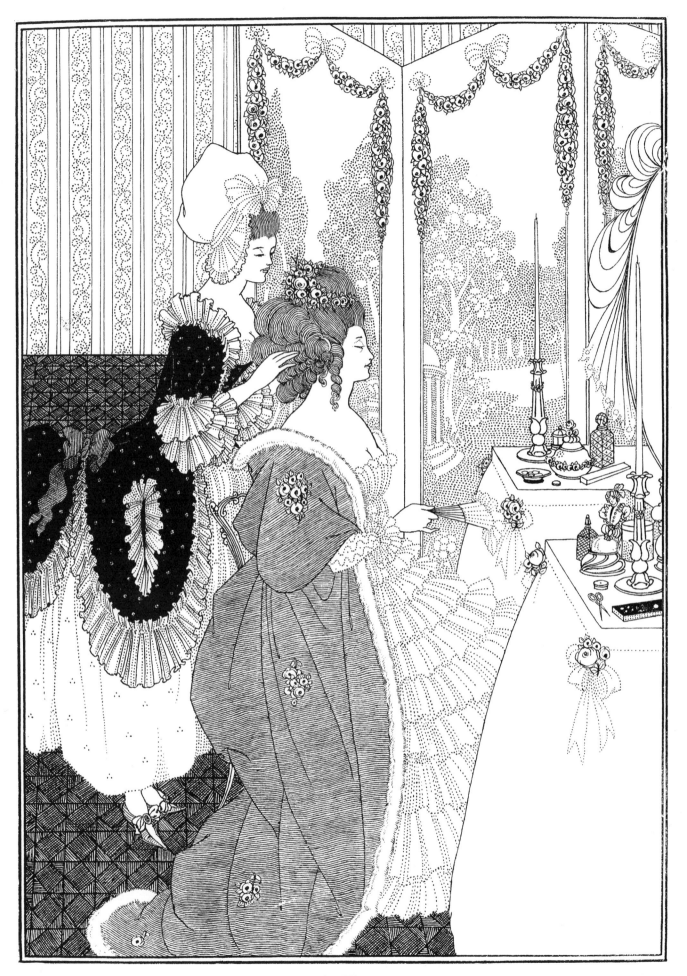

PLATE 48

The Battle of the Beaux and the Belles

This seems to me the best of *The Rape of the Lock* drawings because the attack of the Belle and the collapse of the Beau, who still looks at her with an expression of entreaty, give it more unity of movement than the others in the series. The texture is amazingly rich, but one can't help feeling that it was a pity for Beardsley to spend so much of his precious time on an exercise that did not come from a deeper level of his imagination.

The clothes are a kind of composite *dix-huitième*. The men's coats are more or less of the time of Pope; the ladies' dresses are in a much later fashion. The rococo chair, which echoes the collapse of the Beau, is also considerably later. This *ersatz* eighteenth century was to be employed by commercial art for the next fifty years. The *Morning Post* included this edition in a list of desirable wedding presents and described it as "The Rape of the Lock by Mrs. Beardsley, illustrated by herself." "You see," wrote Beardsley, "how widespread is the doubt about my sex."

Drawing for an illustration in *The Rape of the Lock*
1896
Pen and ink, 10 × 6¾"
Barber Institute of Fine Arts, Birmingham, England

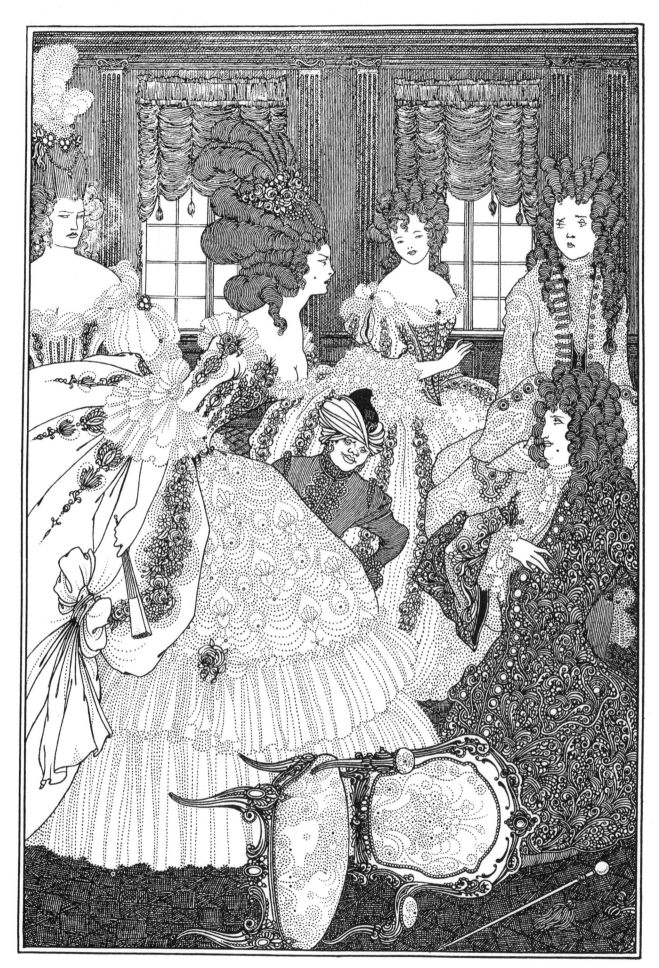

PLATE 49

The Abbé

The dense texture of the illustrations to *The Rape of the Lock* is carried a stage further in this drawing. The claustrophobic effect is intentional and illustrates a passage in Beardsley's story: "The place where he stood waved drowsily with strange flowers, heavy with perfume, dripping with odours. Gloomy and nameless weeds not to be found in Mentzelius. Huge moths, so richly winged they must have banqueted upon tapestries and royal stuffs, slept on the pillars that flanked either side of the gateway, and the eyes of all the moths remained open and were burning and bursting with a mesh of veins." The reader will see why, in the introduction I called Beardsley's prose style absurd; but the drawing is a *tour de force.*

The dandified figure was originally called the Abbé Aubrey, but when *Under the Hill* was published in *The Savoy,* Beardsley had enough discretion to change it to the Abbé Fanfreluche. But why an Abbé? Because the initials AB, pronounced in French, sound like Abbé, so it was an imaginary self-portrait after all.

Drawing for an illustration in Beardsley's *Under the Hill;*
published in *The Savoy,* no. 1
January 1896
Pen and ink, 9¹³/₁₆ × 6⅞"
Victoria and Albert Museum, London. Harari Bequest

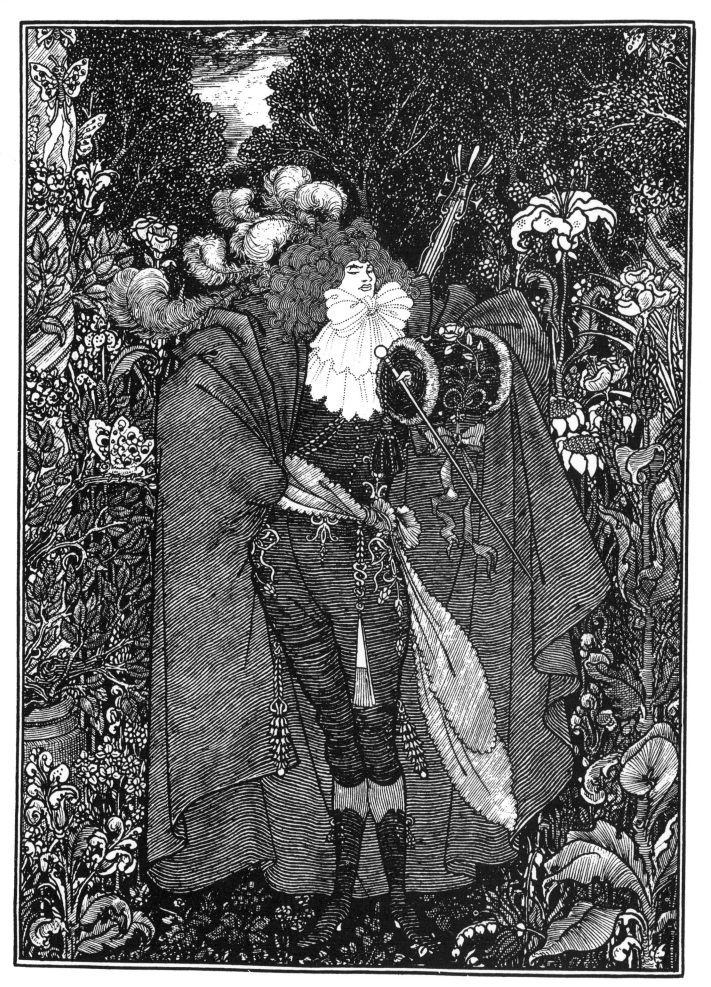

PLATE 50

The Ascension of Saint Rose of Lima

In Beardsley's "romantic story" *Under the Hill* are the waking thoughts of the Abbé Fanfreluche which I quote in the text. One of them is an excursus, too long for quotation, on St. Rose, "the well-known Peruvian virgin . . . who had vowed herself to perpetual virginity when she was four years old." The time came for her wedding. "She . . . put on her wedding frock, and decked her hair with roses, and went up a little hill not far without the walls of Lima; how she knelt there some moments calling tenderly upon Our Lady's name, and how Saint Mary kissed Rose upon the forehead and carried her up swiftly into heaven."

Of all Beardsley's drawings this is the one that reflects most directly the influence of two men who became his friends in his last years, John Gray and André Raffalovich. Both were Catholic converts. The pictorial skill with which Beardsley has conveyed the feeling of ascension closes our eyes to the means by which this has been achieved. Who could put a body within the curious chrysalis of St. Rose? How menacing is the left-hand side of the Virgin's mantle, which is like a monster barking defiance at those who might attempt to interrupt the ascension. Beardsley himself thought this one of his best drawings.

Illustration in *Under the Hill*; published in
The Savoy, no. 2
April 1896
Reproduced from the line block

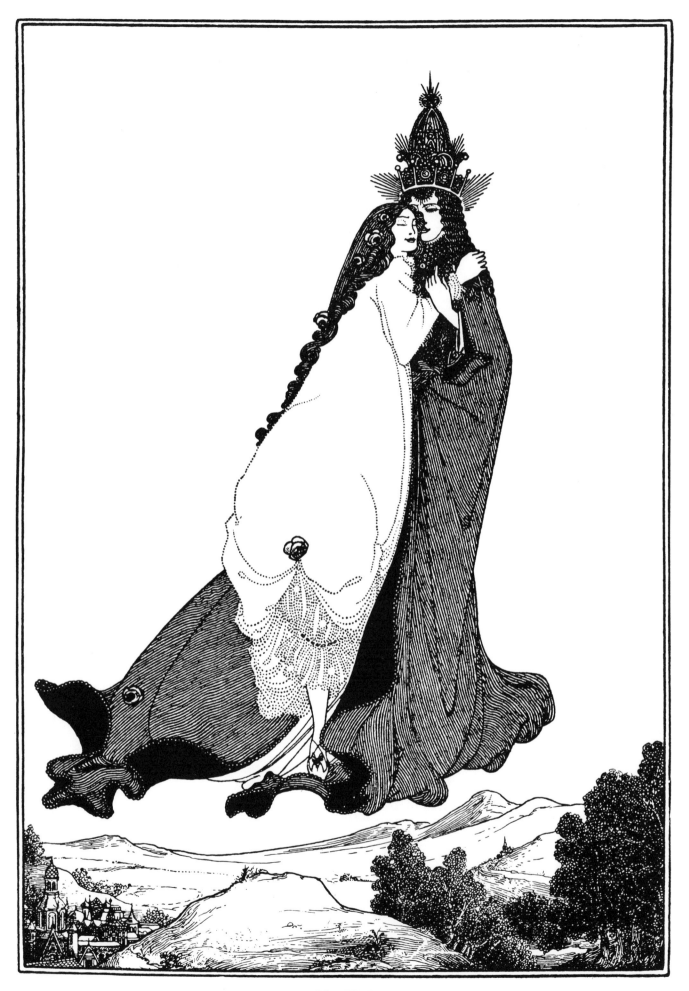

PLATE 51

The Coiffing

This is an illustration of a poem by Beardsley himself, called "The Ballad of a Barber," in which a barber becomes so infatuated by a girl whose hair he is doing that he murders her. Beardsley's poem is ridiculous, but the drawing is admirable and seems to give little hint of the impending drama, but, as Brigid Brophy says with discernment, "the barber's face and wig resemble an eighteenth-century clock implacably telling that time is up for the young princess the barber is going to kill."

The setting of Beardsley's illustration is not at all palatial, but depicts an ordinary middle-class Victorian interior with hideous *Art Nouveau* furniture which is rendered with great precision. The only unusual feature is the figurine of the Virgin and Child on the sideboard in the background. Like *The Ascension of St. Rose of Lima* (pl. 51), this seems to show that Beardsley's interest in the Catholic faith, supported by his two friends Gray and the questionable Raffalovich, had already taken possession of his mind. This could be the reason why the Powers of Darkness deserted him. In this context see *The Death of Pierrot* (pl. 53).

Illustration to Beardsley's poem "The Ballad of a Barber"; published in *The Savoy,* no. 3
July 1896
Reproduced from the line block

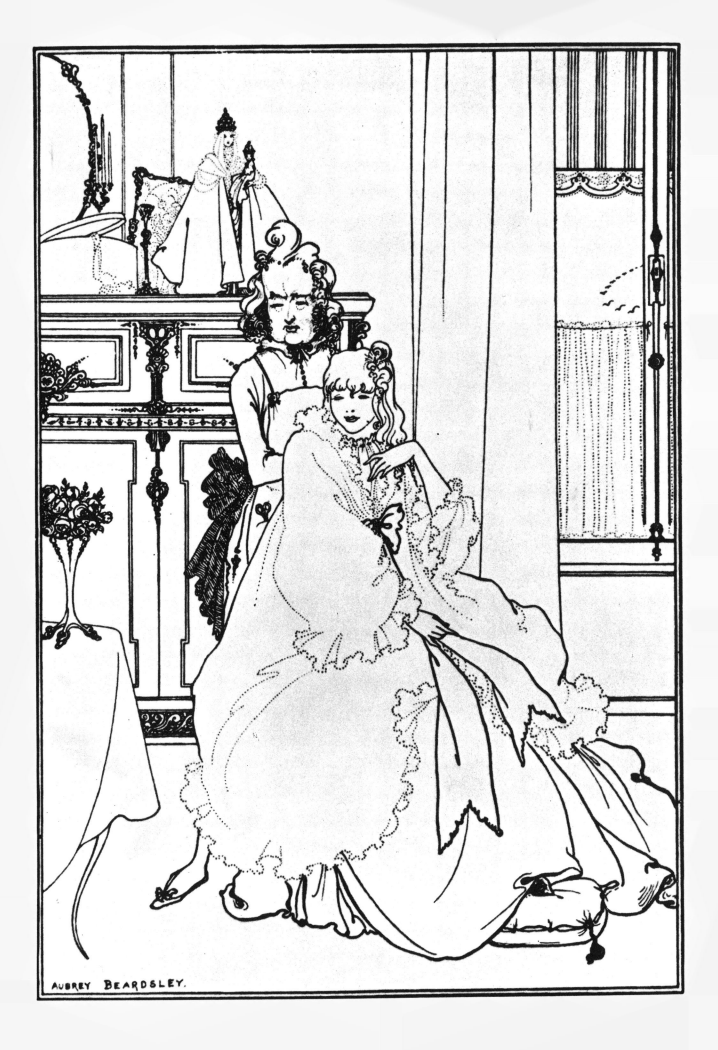

AUBREY BEARDSLEY.

The Death of Pierrot

This is an autobiographical fantasy. The text printed opposite it in *The Savoy* reads: "As the dawn broke, Pierrot fell into his last sleep. Then upon tip-toe, silently up the stair, noiselessly into the room, came the comedians Arlecchino, Pantaleone, il Dottore, and Columbina, who with much love carried away upon their shoulders, the white frocked clown of Bergamo; whither we know not."

Pierrots played an important part in the iconography of the 1890s and survived into the work of Picasso and Rouault. Beardsley did a series of pierrots as illustrations to Ernest Dowson's *The Pierrot of the Minute,* published in 1897. No doubt these pierrot images involved a certain amount of self-identification (see pl. 55). Nevertheless I am not certain that in this beautiful drawing he was thinking of his physical death, but the death of one side of his talent.

Drawing for an illustration in *The Savoy,* no. 6
October 1896
Pen and ink, 8 × 5⅜"
Collection W. G. Good, England

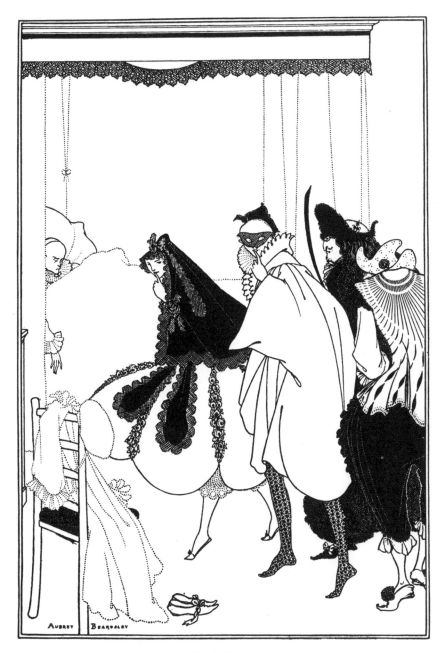

PLATE 53

Ave Atque Vale

This magnificent drawing shows that, even after he seemed to have lost inspiration, Beardsley could use the contrast of black and white of his earlier drawings with masterly effect. It illustrates the poem "Carmen CI" by Catullus that had been translated by Beardsley. It is extraordinary that Beardsley has been able to give an illusion of modeling to the torso, although its white surface is relieved only by a nipple (too far to the right) and a navel.

John Hay Whitney's mother was an early patron of Beardsley, and many unpublished drawings are in his house in Long Island.

Drawing for an illustration to Catullus's poem
"Carmen CI"; published in *The Savoy*, no. 7
November 1896
Pen and ink, 6⅜ × 4⅛"
Collection John Hay Whitney, New York

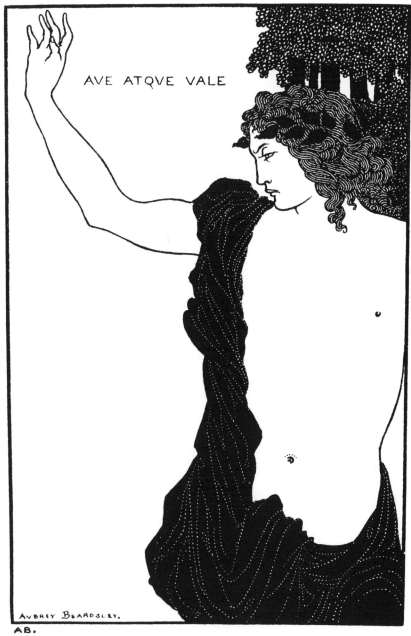

AVE ATQVE VALE

AVBREY BEARDSLEY.

AB.

PLATE 54

Don Juan, Sganarelle, and the Beggar

The two main figures in this beautiful and rather moving drawing are said to be inspired by an engraving of Watteau's *Italian Comedians,* but the resemblance is slight. As so often, the pierrot is Beardsley's idealized projection of himself.

Drawing for an illustration to Molière's *Don Juan;*
published in *The Savoy,* no. 8
December 1896
Pen and ink, 8 × 4¾"

Fogg Art Museum, Harvard University,
Cambridge, Mass. Scofield Thayer Collection

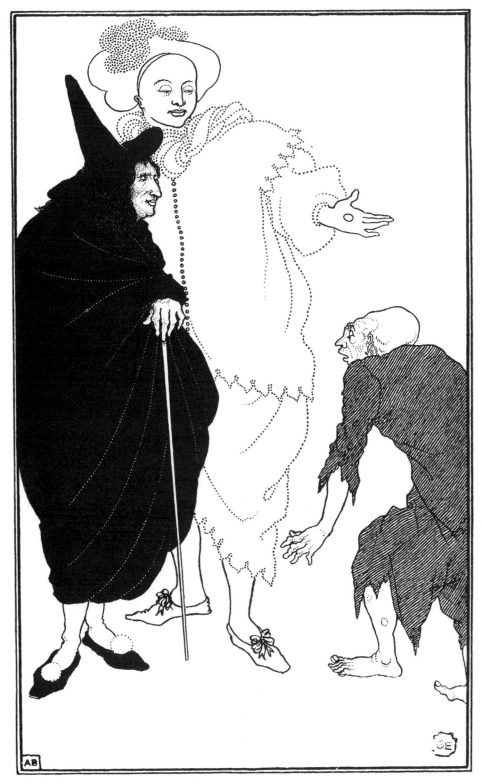

PLATE 55

Apollo Pursuing Daphne (unfinished)

This drawing, known only from a reproduction in R.A. Walker's *Some Unknown Drawings of Aubrey Beardsley* (1923), is one of the most beautiful examples of the pure outline technique of the kind that he was to use in the illustrations to *Lysistrata*. It was clearly unfinished, but Walker says that the left foot was sketched in pencil. The mysterious objects in Apollo's hand are some rushes and the nipple of Daphne's breast. This raises the question of Beardsley's procedures as an artist. Did he sketch in the rest and erase it, or was he so sure of his conclusions that he put in simply what interested him and left off when the drawing pleased him, as in this instance it may well have done!

The drawing is said to have belonged to the great connoisseur of life and art, Count Robert de Montesquiou-Fezensac.

c. 1896
Indian ink and pencil
Present whereabouts unknown

156

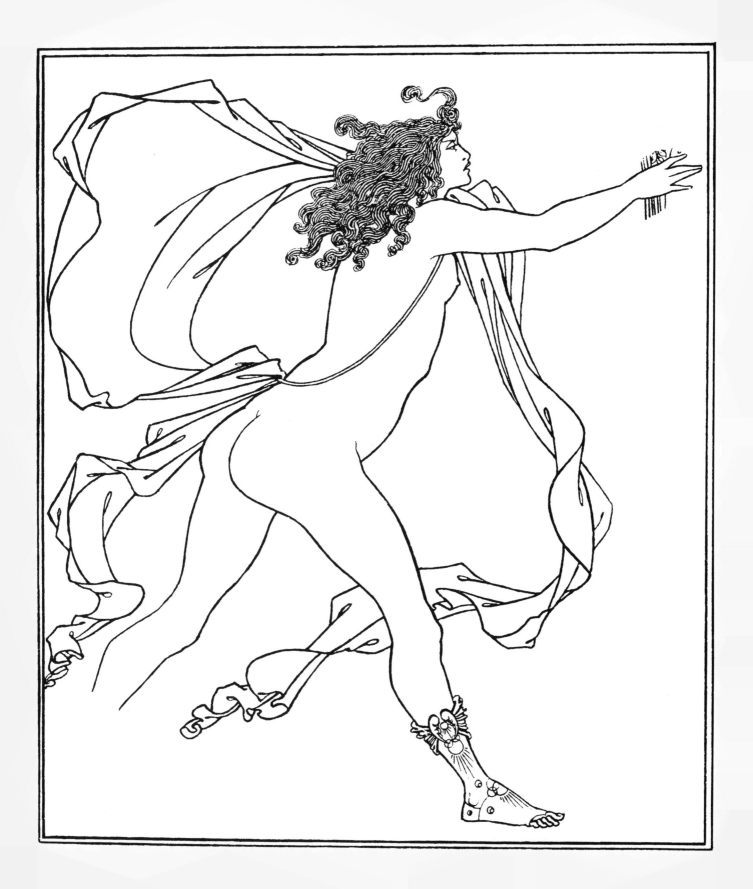

Design for the front cover of
The Savoy, no. 1

Whatever may have been the other results of Beardsley's dismissal from *The Yellow Book,* it seems to have temporarily deprived him of the intensity of vision that had made the *Salome* illustrations start from the pages. He seems to have tried to compensate for this loss by an industrious profusion of detail, apparent in *The Rape of the Lock* illustrations and many of the drawings for *The Savoy.*

This design for the first cover is an example. It is a charming work, but if Beardsley had never done anything different from this he would not have had a place in European art. Incidentally, it shows the rather unexpected interest in flowers, which appears again in *The Abbé* (pl. 50). As far as I know, he never lived in the country or visited a garden, yet the flowers are drawn with considerable understanding.

January 1896
Indian ink and pencil, 14⅝ × 11″
Fogg Art Museum, Harvard University,
Cambridge, Mass. Grenville L. Winthrop Bequest

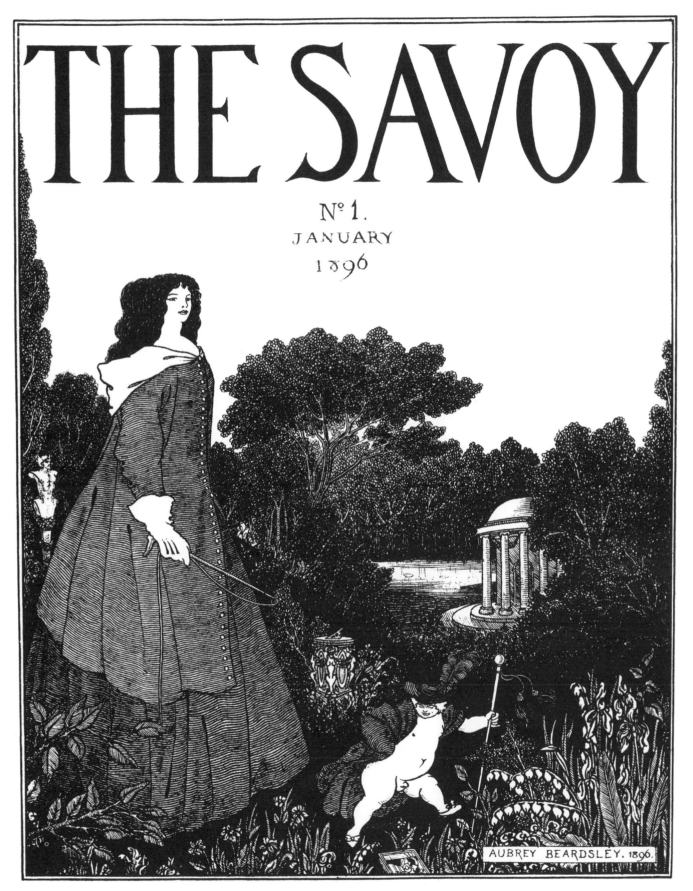

THE SAVOY

Nº 1.
JANUARY
1896

AUBREY BEARDSLEY. 1896.

PLATE 57

Messalina Returning from the Bath

The brutal wickedness of Messalina, which in the color drawing (pl. 45) Beardsley had conveyed by a menacing arch of neck, is here achieved by pure line. The line of the skirt is heavier than usual; the bodice is rendered by dots. The purposeful pose is surmounted by one of the most determinedly evil of all his heads; and yet one recognizes that this is a corrupted variant of his ideal woman in plate 35. The drawing expresses his hatred not (as used to be said) of women, but of corruption, and is thus a pendant to *The Ascension of St. Rose of Lima* (pl. 51). It shows that his letter to Smithers asking him to destroy all his indecent drawings was not merely a deathbed repentance, but something he had long had in mind.

Drawing for an illustration of the
Sixth Satire of Juvenal
1897
Pen and ink, 6⅞ × 5⅝"
Victoria and Albert Museum, London
Harari Bequest

MESSALINA.

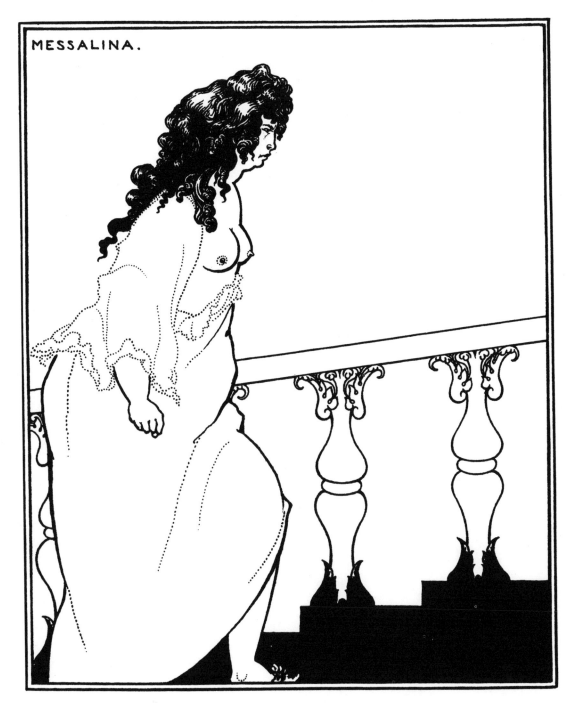

PLATE 58

The Lady at the Dressing Table

These drawings done in the last months of Beardsley's life, show that he had in no way lost his skill. The dull *Savoy* covers were merely a recession. The composition reproduced here, with its suggestion of depth, is something new in Beardsley's art, although how the lady is placed in front of a Hawksmoor church façade is somewhat mysterious. Beardsley has returned to the use of grays as in the early *Studio* drawings, leaving clear black for the mirror and the *chevelures*. The sense of evil has almost disappeared; even the lady's maid lacks the salacity of Mrs. Marsuple. The lady herself shows a great change in Beardsley's sense of feminine beauty. Instead of the impudent "modern" faces, with their short lips and tip-tilted noses, he has depicted her as a type of classic sensuality.

It is tragic to think that by now he must have known that he had only a few months to live.

Drawing for an illustration in *Six Drawings Illustrating Théophile Gautier's Romance Mademoiselle de Maupin*
1898
Pen, ink, and wash, 9¼ × 7½"
Collection Mrs. Pierre Matisse, New York

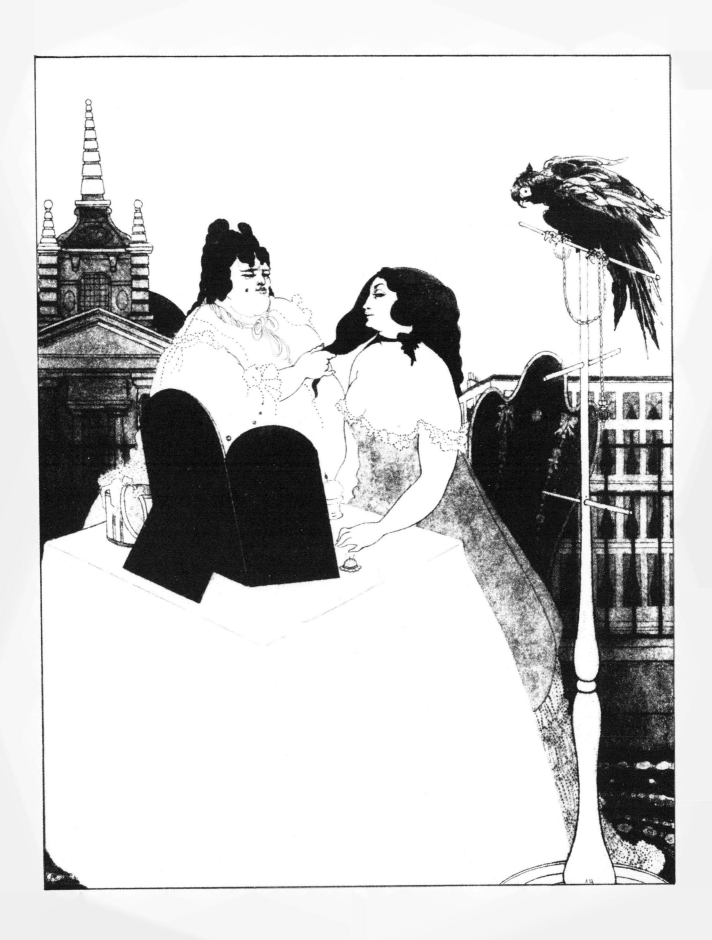

The Lady with the Monkey

After the uninspired years of *The Savoy,* Beardsley, in the last months of his life, evolved a new facial type and a new sense of design. These late drawings are in every way exquisite, and fill one with deep sorrow that he could not have continued and developed this style. The monkey is proof of his extraordinary skill of hand. The drawing is said to have been originally intended as an illustration to *Volpone,* but was rightly included by Smithers in the drawings for Théophile Gautier's *Mademoiselle de Maupin,* where it is more appropriate. No doubt it was done solely for its own sake.

Drawing for an illustration in *Six Drawings Illustrating Théophile Gautier's Romance Mademoiselle de Maupin*
1898
Pen, ink, and wash, 7⅞ × 6⅝"
Victoria and Albert Museum, London
Harari Bequest

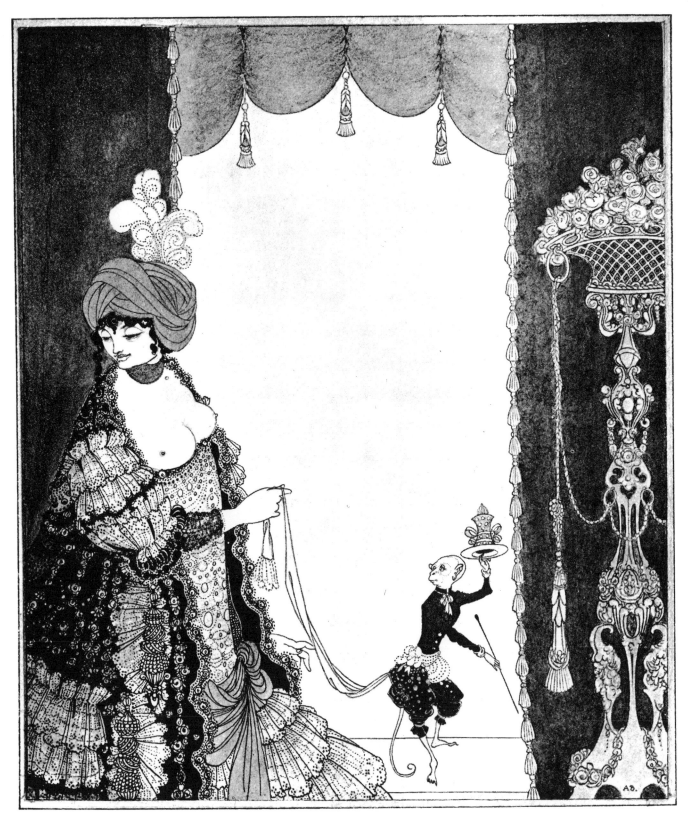

PLATE 60

Design for the front cover of
Ben Jonson; his Volpone; or, The Foxe

Like the study for the cover of *Salome,* this shows how freely Beardsley could draw if the occasion demanded it. It is signed A B and dated Paris 1898, so must have been done just before the cold weather forced him to retire to Menton.

1898

Brush and ink, 11 × 8³/₁₆″

*Fogg Art Museum, Harvard University,
Cambridge, Mass. Scofield Thayer Collection*

VOLPONE

PLATE 61

Volpone Adoring His Treasure

This is Beardsley's last great drawing and was probably done in Menton a few weeks before his death on March 16, 1898. It represents the opening lines of the drama:

> Good morning to the day; and next, my gold:
> Open the shrine, that I may see my saint,
>
> (Mosca withdraws the curtain and discovers piles of gold, plate, jewels, etc.)
>
> Hail the world's soul, and mine.

Smithers had commissioned Beardsley to illustrate *Volpone* when he was in Paris in January, 1898, and published the six drawings he completed immediately after his death. The other five are initials in pen and wash and are not very successful, but the *Volpone* is drawn with admirable firmness and authority. The characterization of the head is masterly. In this, and the design for the front cover (pl. 61), Beardsley still seems to be at the height of his powers.

Drawing for the frontispiece of *Ben Jonson; his Volpone; or, The Foxe*
1898
Pen and ink, 11½ × 8"
Princeton University Library, Princeton, New Jersey

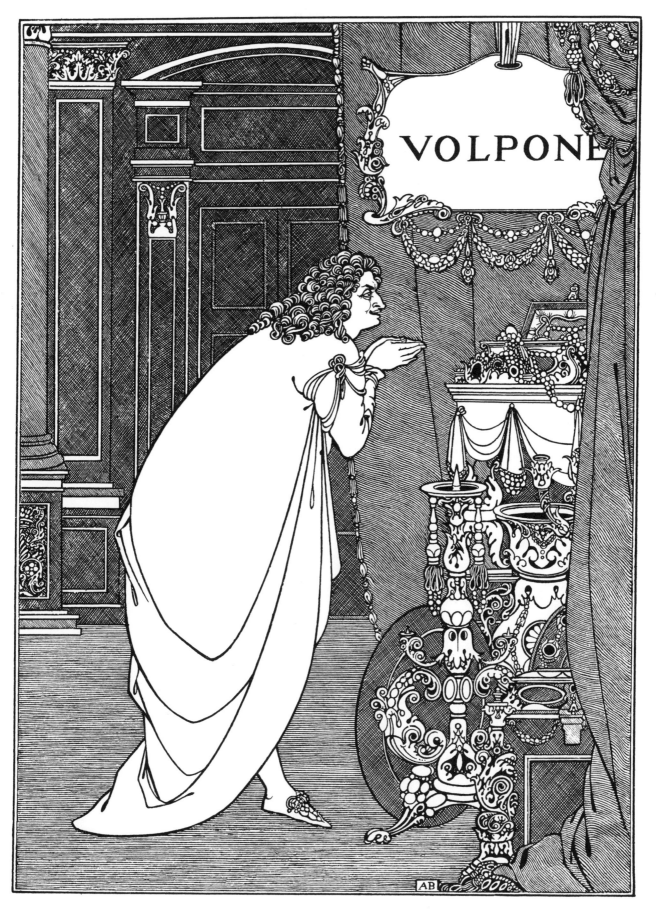

VOLPONE

PLATE 62

Index